SPECTACULAR HOMES
of Michigan

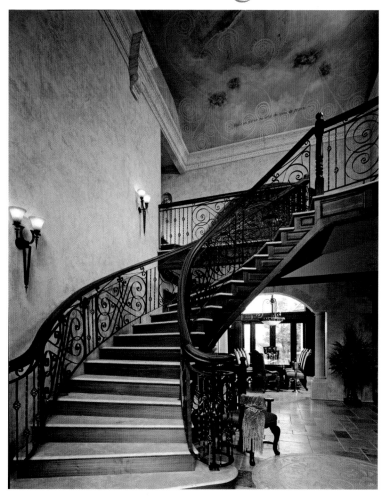

AN EXCLUSIVE SHOWCASE OF MICHIGAN'S FINEST DESIGNERS

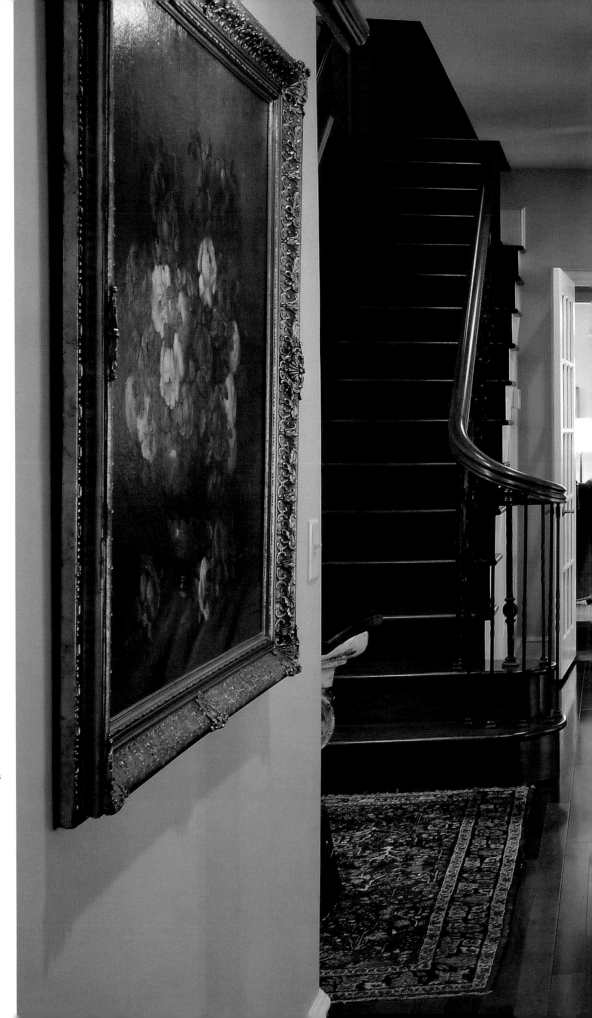

Published by

PANACHE
PARTNERS LLC

13747 Montfort Drive, Suite 100
Dallas, Texas 75240
972.661.9884
972.661.2743
www.panache.com

Publishers: Brian G. Carabet and John A. Shand
Editor: Khristi Zimmeth
Design: Emily Kattan

Printed in Malaysia

Distributed by Gibbs Smith, Publisher
800.748.5439

PUBLISHER'S DATA

Spectacular Homes of Michigan

Library of Congress Control Number: 2006929748

ISBN 13: 978-1-933415-16-1
ISBN 10: 1-933415-16-9

First Printing 2006

10 9 8 7 6 5 4 3 2 1

Previous Page: Tim O'Neill & Stephanie Harrington O'Neill, O'Neill Harrington Interiors
See page 99 *Photograph by Beth Singer*

This Page: Janet Child Chism, Janet Chism Design
See page 23 *Photograph by M-Buck Studio*

SPECTACULAR HOMES
of Michigan

AN EXCLUSIVE SHOWCASE OF MICHIGAN'S FINEST DESIGNERS

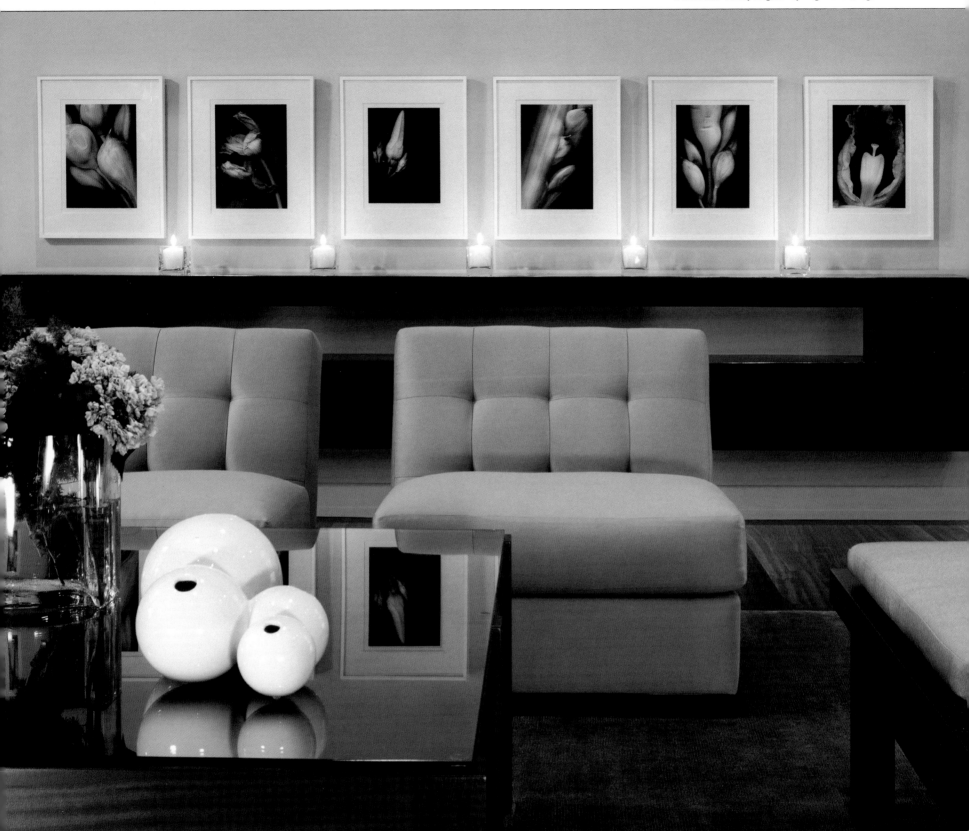

As a Michigan-based home and design writer, I am treated to insider tours of spectacular homes on a regular basis. Not a week goes by where I'm not asked to take "a sneak peak" at a just-finished project by a top designer, write about an upcoming trend in interior design or preview a hot-off-the-press interior (I know; it's a tough job, but someone has to do it). During my travels around the state, I am consistently impressed by the creativity and dedication of the designers I am privileged to work with. Their passion for every project they take on continues to excite and inspire me.

Like beauty, a spectacular home is in the eye of the beholder. I believe a spectacular home is one that truly reflects the interests and passions of its inhabitants. I love homes filled with antiques, well-read books and collections gathered from years of treasure-hunting, be it at a local flea market or a far-flung market. Personal interiors excite me, whether they are my taste or not. I appreciate the effort and enthusiasm that goes into them.

What excites me, however, may leave you cold. That's why in this book we strive to present a wide variety of styles, looks and professionals. One is sure to work for you and your home.

Michigan, the Great Lakes State, is blessed with an abundance of natural beauty. Our lakes and our land are second to none. Through this book, we hope to show you that our manmade beauty—in the forms of our beautiful home interiors and personal spaces—can make the same claim.

We hope you enjoy this insider's tour of our great state.

Khristi Zimmeth

Khristi Zimmeth
Editor

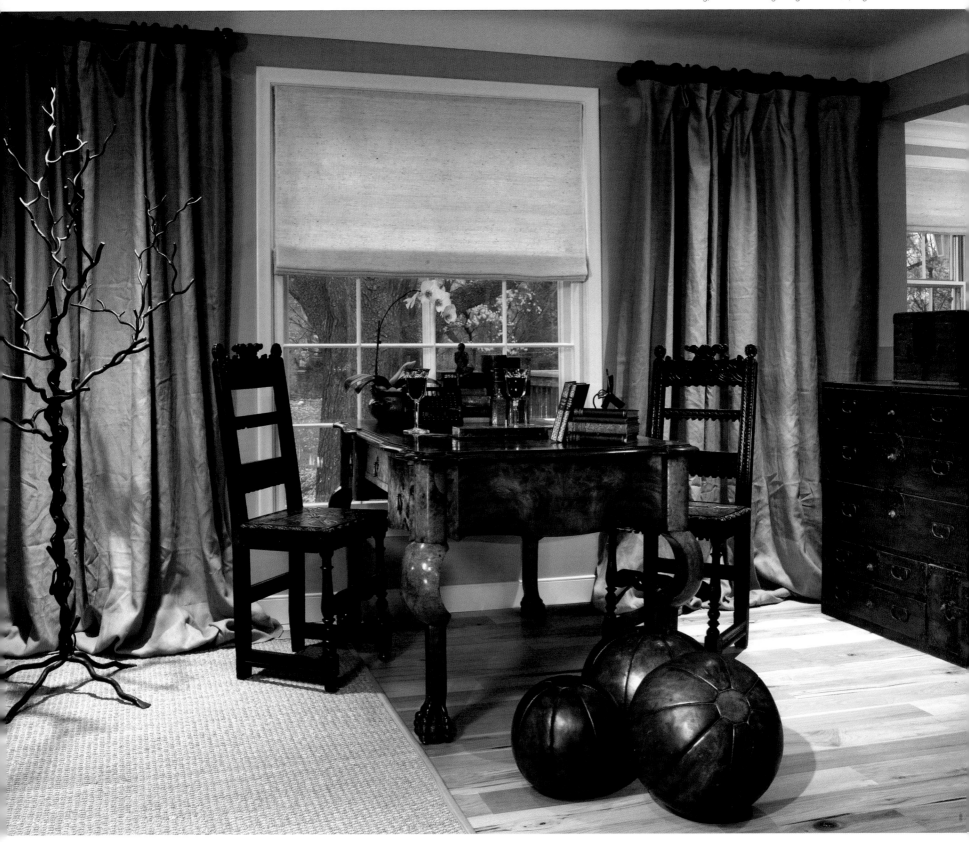

TABLE OF CONTENTS

Rock Home Studio, *Page 69*

"PAINT THE WALLS A BEAUTIFUL COLOR, SOMETHING
YOU WOULD LIKE TO LIVE WITH EVERY DAY."
WENDY REEVE

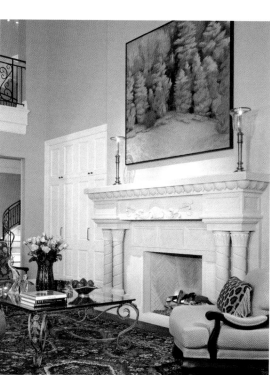

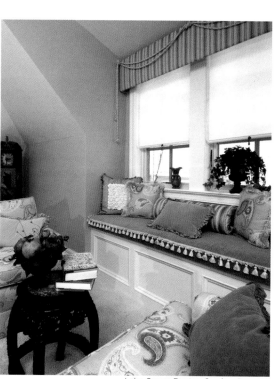

Janet Chism Design, *Page 23* Innovative Interiors, Inc., *Page 27* Lake Street Design Studio, *Page 49*

"No room is complete without an interesting variety of incandescent lighting."

BRIAN CLAY COLLINS, ASID

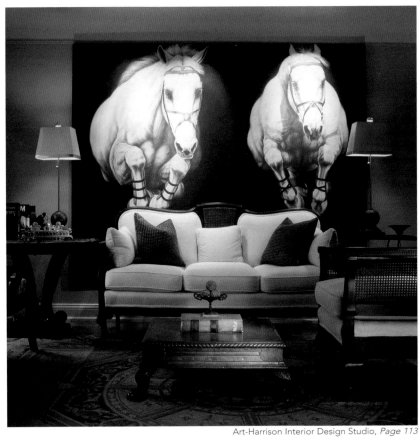

Art-Harrison Interior Design Studio, *Page 113*

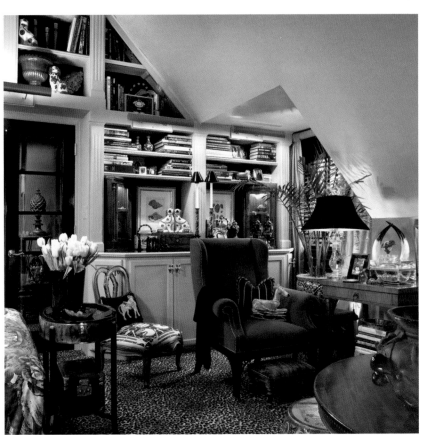

Brian Collins Interior Design, *Page 29*

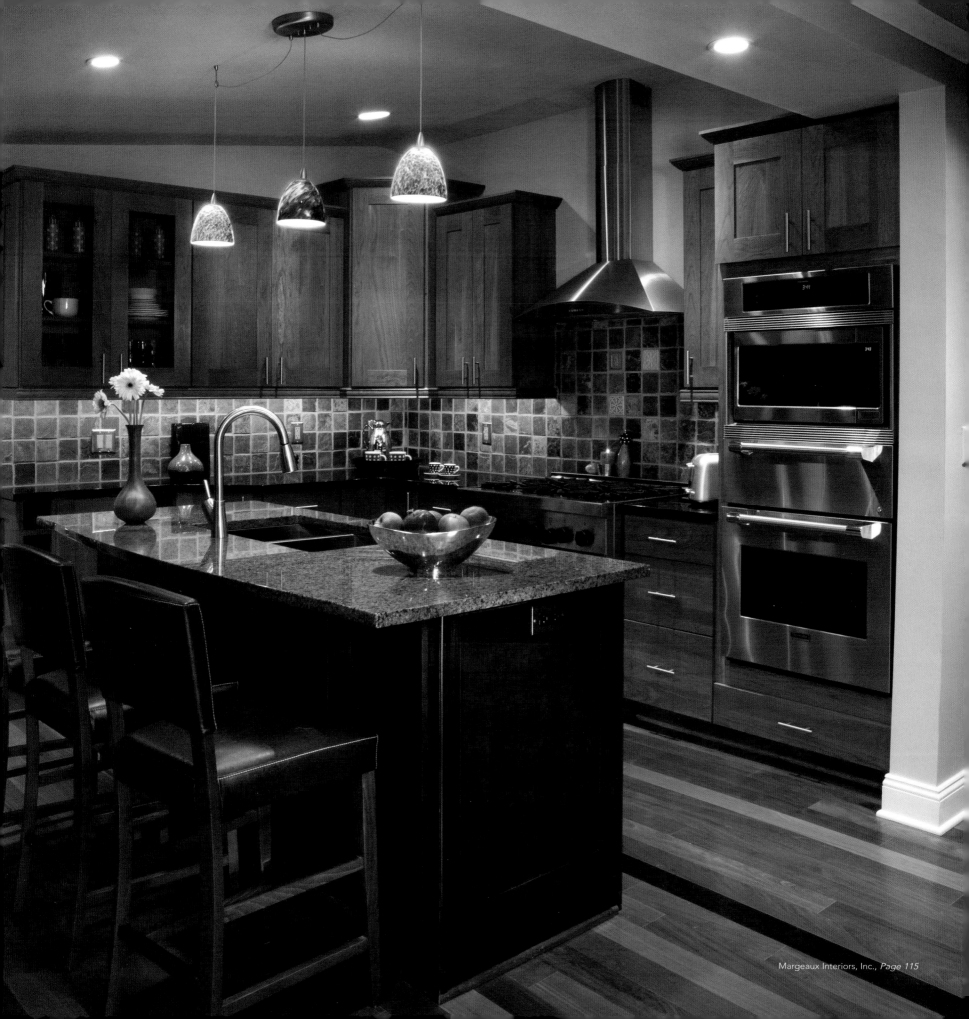

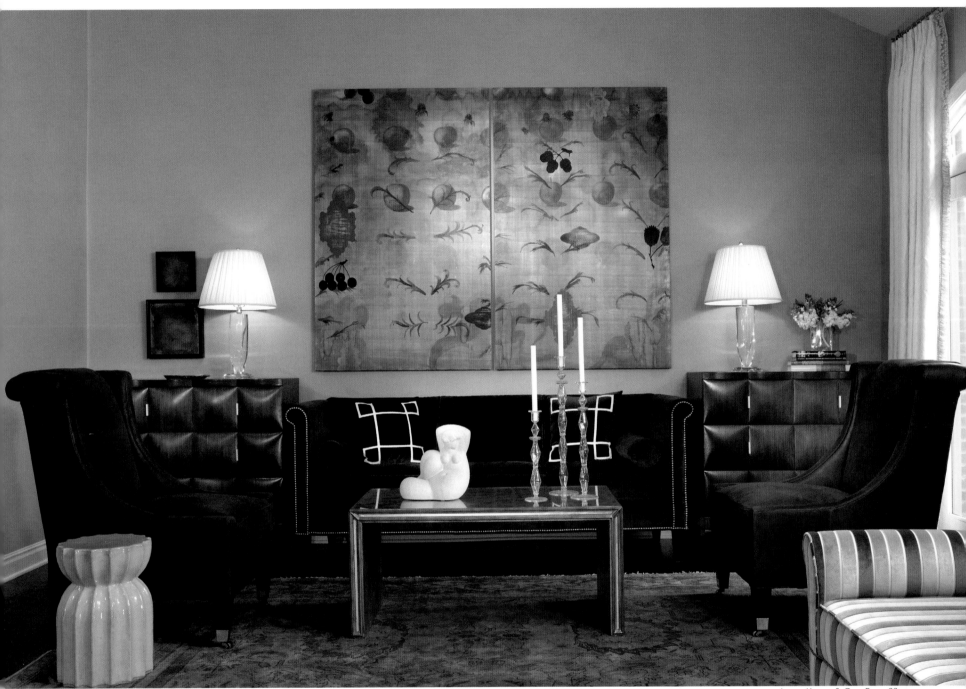

Jones-Keena & Co., *Page 33*

"IN THE END, NO ROOM IS COMPLETE WITHOUT THE PERSONALITY OF THE OWNER."

DJ KENNEDY

TK Designs, *Page 83*

DMJ Interiors, *Page 57*

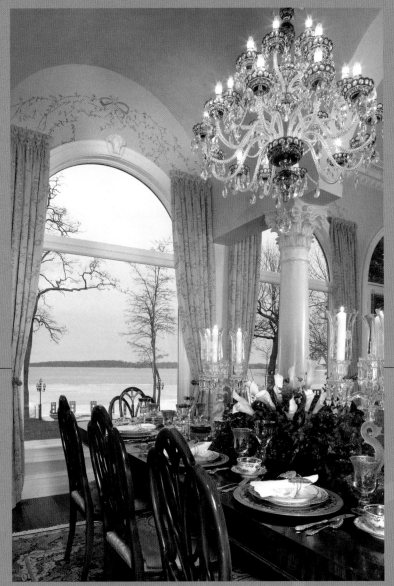

DESIGNER: Josephine Sesi Kassab, J.S. Kassab Interiors, *Page 63*

Michigan

AN EXCLUSIVE SHOWCASE OF MICHIGAN'S FINEST DESIGNERS

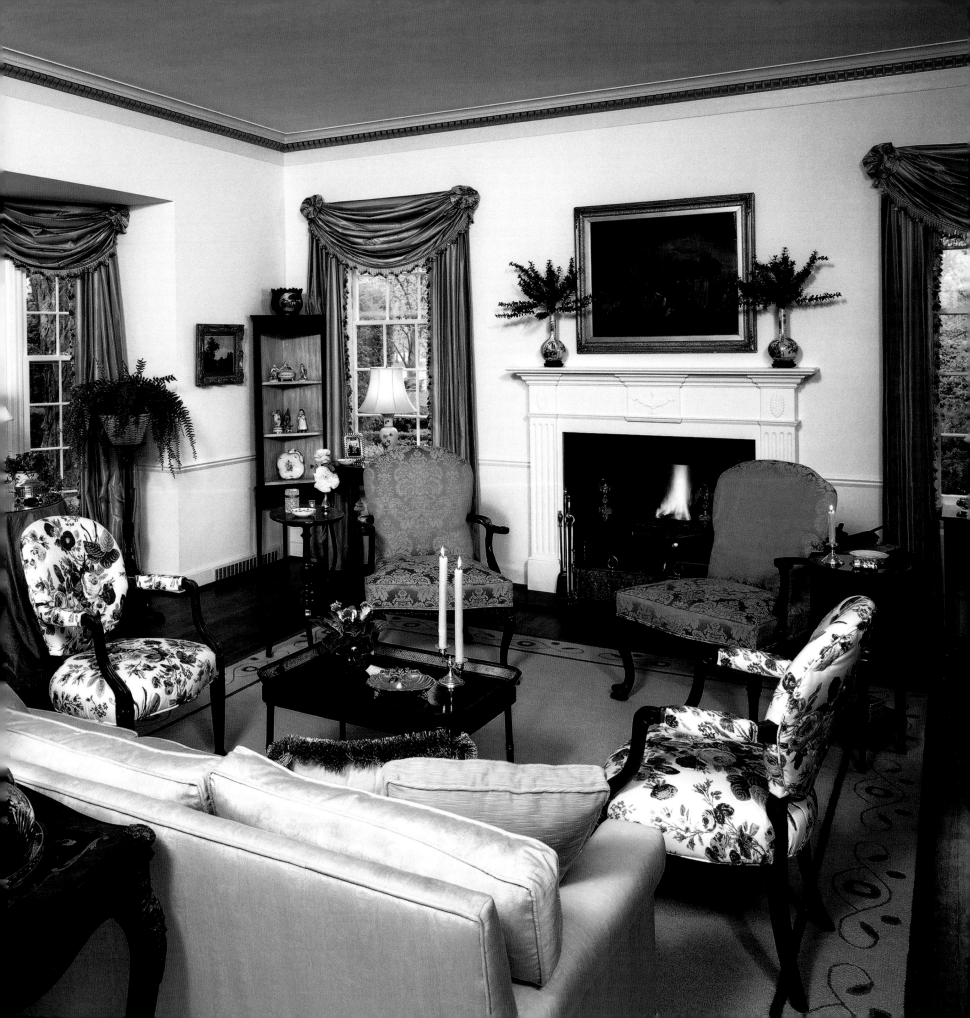

LINDA AXE

L.V.L. ENTERPRISES

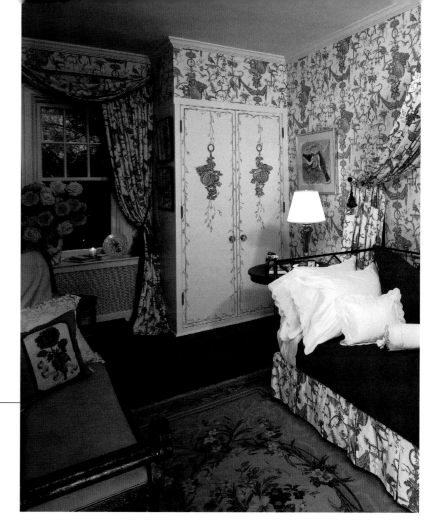

"Everyone loves this house," says Grosse Pointe Farms designer Linda Axe of her 1935 Georgian Colonial adjacent to the 1920's Country Club of Detroit. "I never, ever want to move." It's easy to see why. Besides the enviable location, the comfortable and traditional home is the site of her thriving design business and the perfect example of Axe's design style, a classic yet cozy look that features a mix of fine antiques, timeless furniture and well-chosen accessories.

"I believe in homes that are livable and true reflections of the people who inhabit them," she says. Axe and her husband, John, have been in the house for 13 years and have had to redecorate every room.

"My father was a huge collector and my family loved antiques," says the designer, who grew up on a farm near Indianapolis. "I definitely got my interest in antiques from my family."

Her eye, however, is all her own. Culled from her days as a student at the Parsons School of Design, where she studied Interior Design, it was furthered in early experiences in floral design. Her floral creations are featured in private homes around

the U.S. as well as in the Metropolitan Club and the Metropolitan Museum in New York City. Her look is traditional with an eclectic twist—much like Linda herself. Her interests don't determine how her clients design their own homes, however. "I design a client's house to look like the client, not like me," she says. "I want their homes to be a true reflection of who they are—and who they want to be."

ABOVE
This guest bedroom uses a Brunschwig & Fil fabric as wallpaper. The fabric is an English design inspired by an early toile from 1789. The room also features a Hortense daybed.
Photograph by Jeff Garland

LEFT
The designer's personal living room is filled with fine antiques, timeless furniture and well chosen accessories.
Photograph by Jeff Garland

L.V.L. ENTERPRISES
Linda Axe
481 Kercheval
Grosse Pointe Farms, MI 48236
313.881.1981
Fax: 313.886.7287

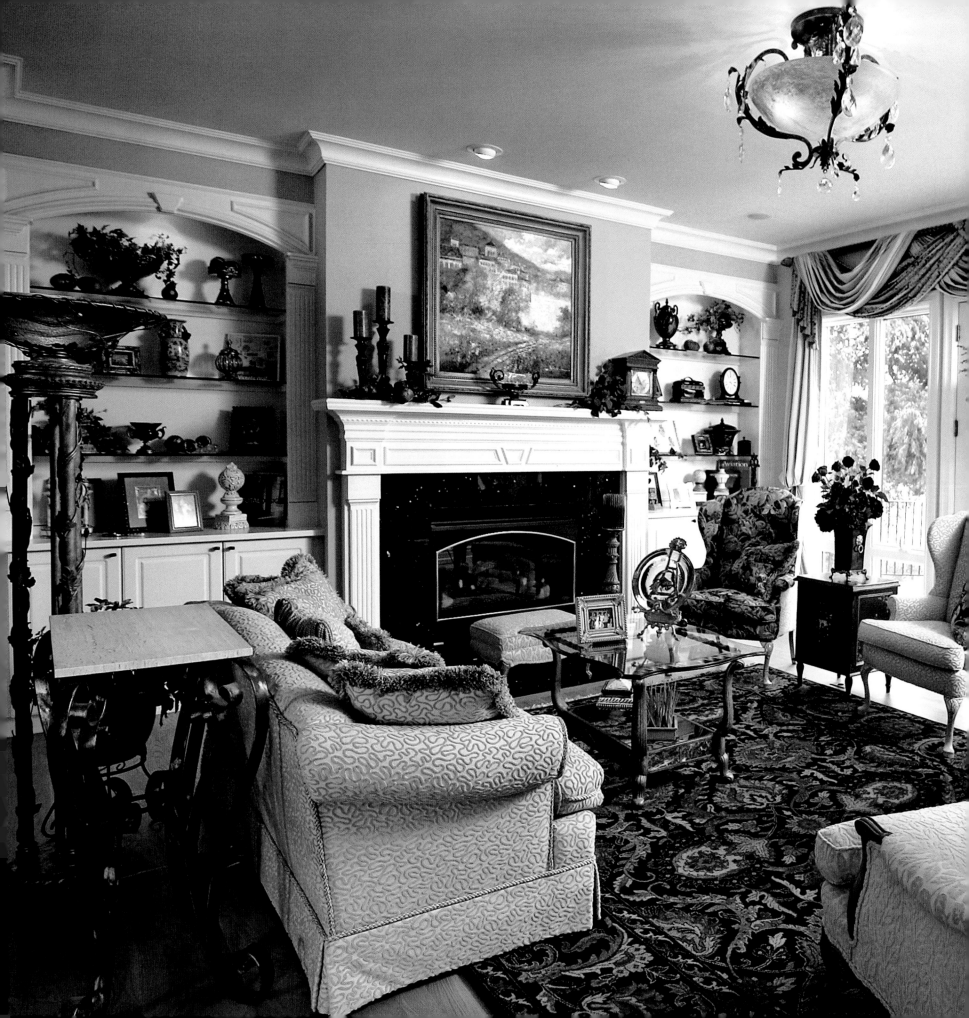

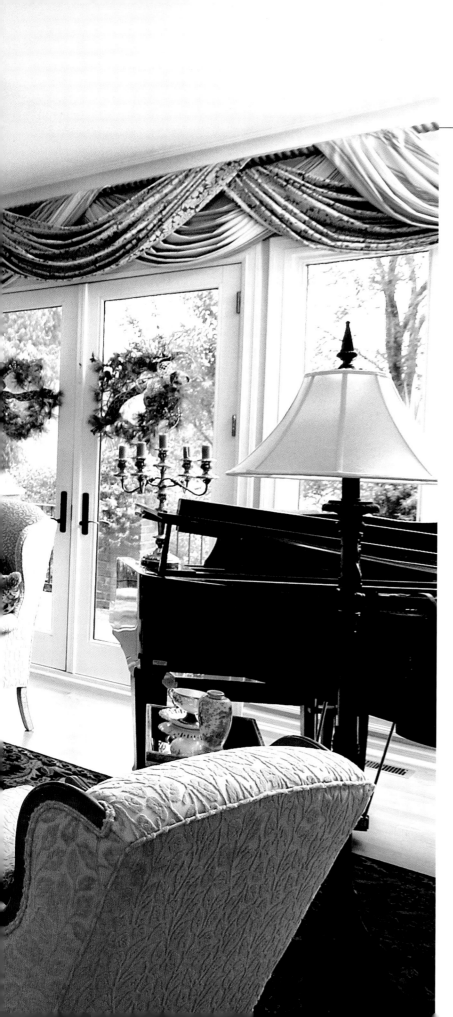

DONNA BROWN
DAZZLING DESIGNS

Four years in San Antonio, Texas, made a huge impact on Donna Brown of Northville's Dazzling Designs.

"It certainly has widened my perspective," the designer says. "Texas design is far more innovative; here in Michigan we're more conservative. When they were doing iron, stone, and crystal in San Antonio, we were still doing wood and brass."

Texas style has filtered into many of the homes Brown designs for her clients, she says. Popular Lone Star State elements include natural stone, granite, iron, and a look that's generally "more than a little Mediterranean," she says. "In Texas, they like an Old World influence, with a variety of different textures and mediums."

The versatile Brown strongly suggests many of these materials to her clients. Every job reflects its own special look for a unique design and is customized for the client.

"Some people are ready, some aren't," she says. "I listen to the client. I can do any style, but the majority of clients seem to be after something transitional, which is mainly traditional with a little contemporary. I hear the word infusion a lot, which is a mix of different looks and styles."

Knowing when to push—and when not to—has made Brown a successful designer for more than a dozen years. She purposefully stays small—there's just her and a part-time assistant—and limits the number of clients she takes.

"I could work seven days a week, 24 hours a day if I wanted to," she says. "I'm generally juggling about 10 clients at a time."

LEFT
This living room furniture features an Indian design on a black background. Upholstery includes light-textured velvet and tapestry fabrics by Kravet. Lighting fixture made of alabaster, iron and crystal by Frederick Raymond.
Photograph by Rosh Sillars

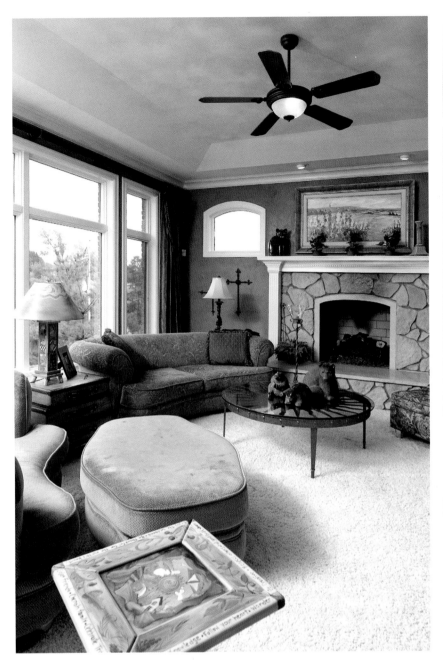

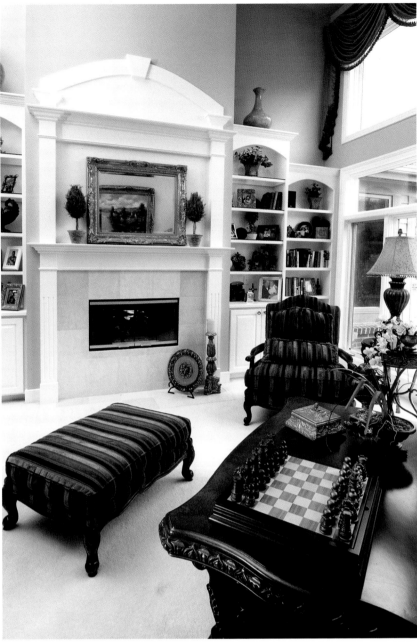

She also offers another skill: great organizational abilities. She left a degree in accounting and a prior career as a plant manager to become a designer. "At one point I was in operations management in the auto industry," she says. "Design and working independently was just a better fit for my family and me, although my business skills have been a huge asset," she says.

She enjoys working in a wide variety of styles and tailors each project to its owner.

"My time in the Southwest has definitely given me an edge, but I believe the room has to fit the client.

I don't want the houses I do to look like a "Donna Brown house. The best compliment you can get is that the house is truly a reflection of the homeowner."

ABOVE LEFT
This limestone and Durango hearth and trim fireplace is the focus of this living space. The coral chenille upholstered furniture, accented with blue/purple tones, is by Pindler & Pindler. The wood flooring is given the added "warmth" of a shag rug. Venetian-finished walls and silk tone-on-tone fringed drapery by Fabricant bring together the desired look. The ceiling's faux-painted sky adds a finishing touch and further brightens the feeling of the room.
Photograph by Rosh Sillars

ABOVE RIGHT
Fireplace of marble and wood trim tie beautifully into the handsome custom cabinetry. Richly colored striped velvet furniture is by Hickory Chair.
Photograph by Rosh Sillars

FACING PAGE
This kitchen features medium-tone maple cabinets with chocolate glaze and stainless steel commercial appliances. Counters are Emerald Pearl and Santa Clara granite while complementary backsplash features crackled tiles with granite inserts. Further elements including the iron and glass light fixtures, wood floors, and Tibetan rugs complement the overall appearance of this highly functional yet aesthetically pleasing kitchen.
Photograph by Rosh Sillars

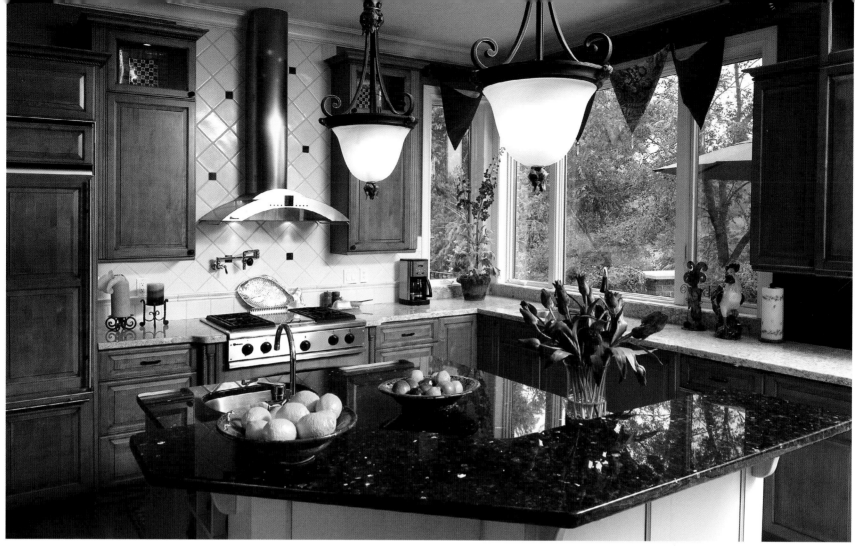

MORE ABOUT DONNA...

DAZZLING DESIGNS
Donna Brown
18659 Fox Hollow Court
Northville, MI 48167
248.380.5043
Fax: 248.380.5044
dazdesigns@aol.com

WHAT PERSONAL INDULGENCE DO YOU SPEND THE MOST MONEY ON?

I like nice things and good service. We golf a lot. I love beach vacations, shopping at Nordstrom's, and spending time with my husband and sons.

NAME ONE THING MOST PEOPLE DON'T KNOW ABOUT YOU.

In my past life I was a plant manager. Design is a second career. After living in the south, I dread giving up my sandals at the end of the summer. I'll wait until my feet are freezing.

WHAT IS A SINGLE THING YOU WOULD DO TO BRING A DULL HOUSE TO LIFE?

Paint! Introduce color and add handwoven rugs, trim or molding. It makes a huge difference.

WHAT BOOK ARE YOU CURRENTLY READING?

A Million Little Pieces by James Frey.

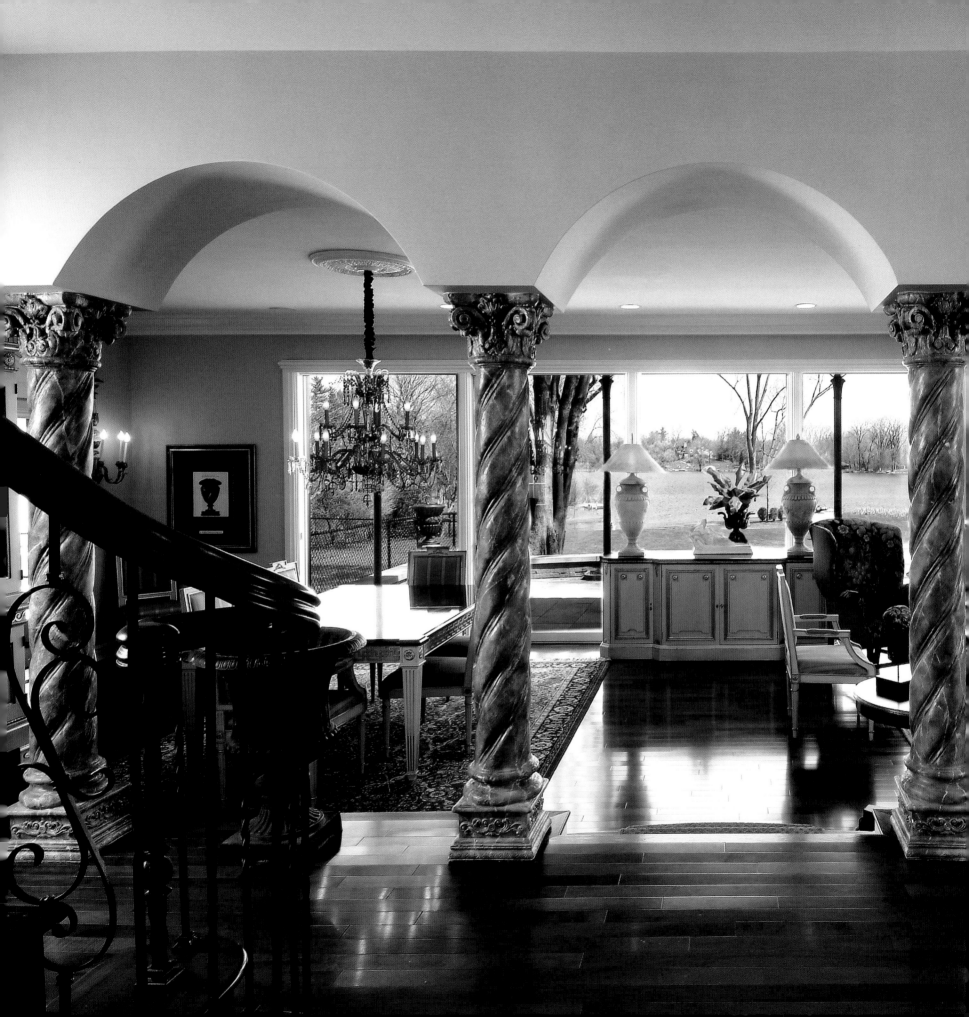

JANET CHILD CHISM
JANET CHISM DESIGN

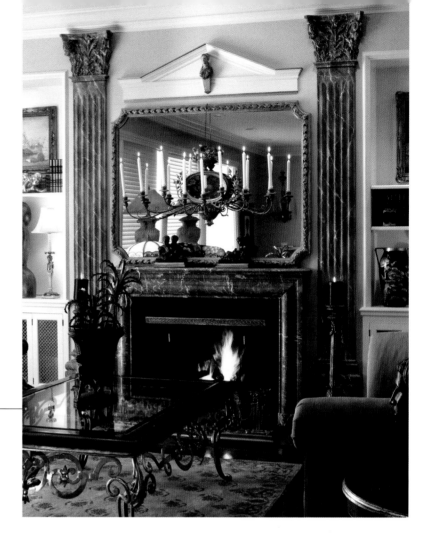

Janet Child Chism has designed many homes, but few have been as rewarding as working on her family's 1926 Arts and Crafts cottage in Bay View, Michigan, when she was 14 years old.

"I fancied myself a decorator and was given free reign to redo a bedroom and half bath in my mother's summer cottage," she remembers. "It was the 1960s, and the orange and yellow colors and psychedelic patterns were totally wrong for the structure," she muses. "It did, however, instill a love of design in me at an early age."

While the interiors she designs today are more sensitive to the architecture of the home they reflect, that love has served her well.

She's clearly moved past the psychedelic '60s and now embraces historically accurate interiors.

"I believe in looking at the house and era and respecting the architecture," she says. "The two should complement one another. I enjoy working on homes that have historical significance."

Her own house is a 1959 Italianate-style home built for Hollis Baker Sr., owner of Baker Furniture. On two acres, it backs up to a quiet lake while only ten minutes from downtown Grand Rapids. The Baker furniture showroom in North Carolina is modeled after the house.

"I had loved this fine residence from the exterior for years and told a favorite Realtor if it ever came on the market to call me." An upstairs water leak, before her family moved in, set the stage for a complete redo. "We removed walls to increase the view of the lake, opened the flow and made the home our own." Janet's kitchen design won the award for Best Kitchen of the Show at the Remodeler's Parade of Homes.

Besides working on homes throughout the state, Chism works with Realtors who are interested in properly "staging" homes for quicker resale. Her services are particularly

ABOVE
Drawn on the original 1950's blueprints but not implemented until 2005, the faux-finished fluted pilasters frame the 18th century French marble surround.
Photograph by M-Buck Studio

LEFT
Dramatic arches and antique columns celebrate the classical symmetry evident throughout the home. Fisk Lake creates the beautiful vista.
Photograph by M-Buck Studio

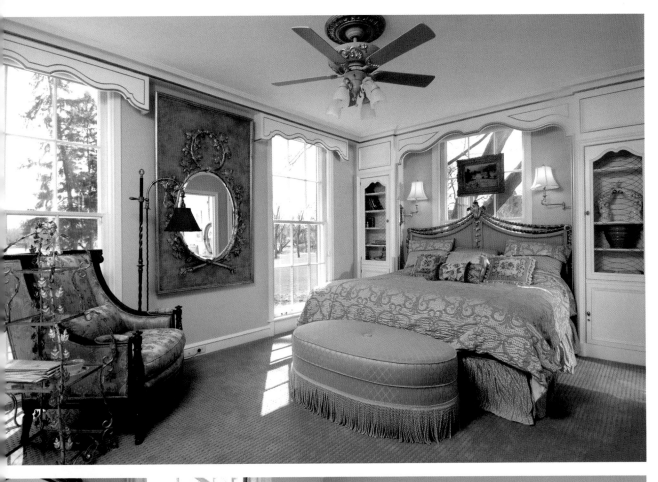

in demand these days with the highly competitive Michigan real estate market. Her vast business inventory consists of furnishings and accessories capable of handling homes from traditional in style to very contemporary and eclectic.

Originally from Findlay, Ohio, Janet graduated with a Bachelor of Arts in art and design and has lived in New York City, Tulsa, Oklahoma and a variety of places in between. In each place she's lived she's had a business with an artistic bent. Each area of the country has given her a special appreciation for its unique flavor. She decided to devote herself to interior design after moving to Grand Rapids in 1997.

Not long ago, she redecorated her mother's cottage again—this time, the right way.

"My mom lived with the 1960s look for decades," she says. "When I went back to do the design as an adult, I listened to both the house and my mother, and incorporated the right interior and exterior colors, the proper vintage wicker furniture, and period stained glass."

And her mom? "She loves it!" says Chism. "I figure if you can please your mother, you can please anyone."

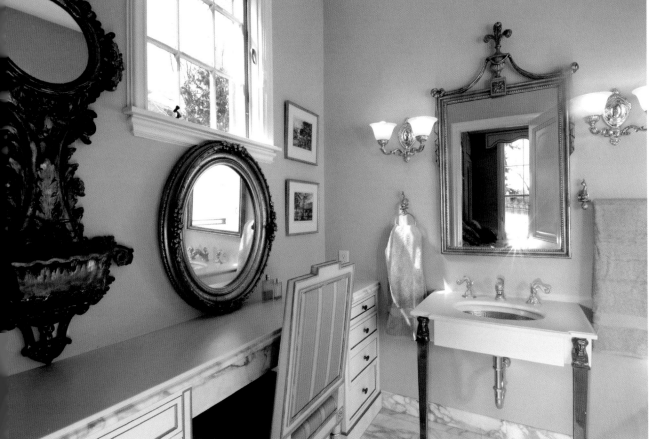

TOP LEFT
Ornate cornices and original millwork from the Baker Furniture Company, Grand Rapids, adorn the luxurious master suite. Other than furniture and accessories, this room remains essentially the same as when the residence was featured in *Architectural Digest* in the mid '60s.
Photograph by M-Buck Studio

BOTTOM LEFT
The elegant look from the master bedroom is carried through to the master bath. The basin and fixtures are by Sherle Wagner.
Photograph by M-Buck Studio

FACING PAGE LEFT
An eclectic use of materials in this bathroom is expertly pulled together to create a well composed twist.
Photograph by M-Buck Studio

FACING PAGE RIGHT
The removal of the dropped ceiling and the return to the original 10' height created many opportunities for focal points, including this lovely hood.
Photograph by M-Buck Studio

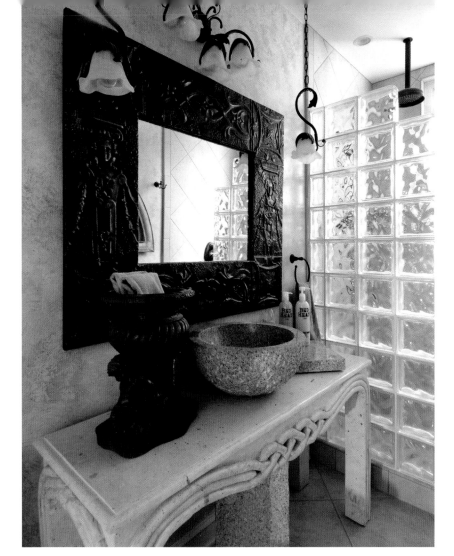

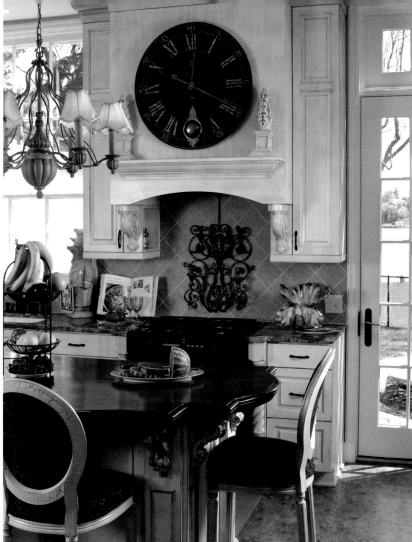

MORE ABOUT JANET...

Good design has no expiration date.

Antique wicker, circa 1880-1920.

My parents wonderfully encouraged me and influenced my creative development. My father always supported everything I wanted to try with a 'Go for it!' attitude; my mother accompanied me to art museums and exhibits and taught me to understand and appreciate beauty and quality. My husband has encouraged me in each new endeavour, whether a retail shop in New Jersey, an antique shop in Richmond, Virginia, or a design career in Grand Rapids.

JANET CHISM DESIGN
Janet Child Chism
Grand Rapids, MI
616.550.2161

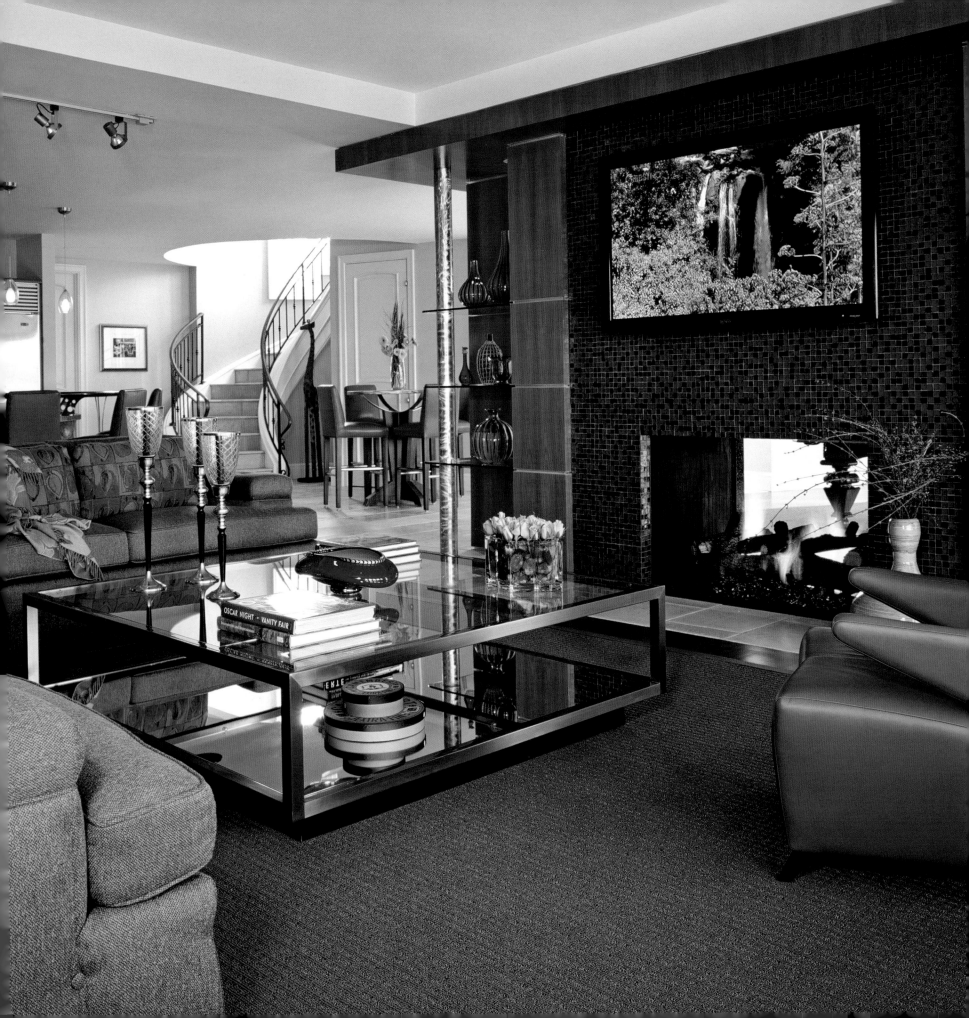

ARLENE COHEN & ROBBIE SEGEL

INNOVATIVE INTERIORS, INC.

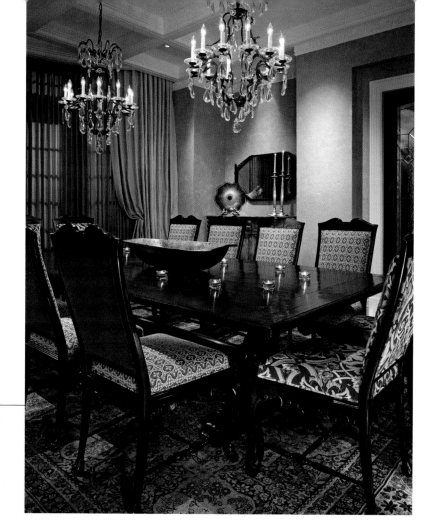

Arlene Cohen and Robbie Segel met while studying interior design at Wayne State University. Partners for more than 18 years, they run a thriving business in West Bloomfield built on their separate strengths.

While each has her own clients, behind the scenes they work as a team. "Clients usually only interact with one of us, but we consult on all projects, giving each the benefit of our individual and combined creativity," says Robbie.

The firm recently completed a 20,000-square-foot home in Oakland County.

The English-style residence features hand-carved moldings and distressed wood floors with limestone and glass mosaic fireplaces.

Cohen was involved in the project from its initial concept through architectural design, construction and all interior design specifications.

The home features stunning antiques including Persian rugs, French armoires and tile and stone imported from all over the world.

The challenge, says Arlene, was making a large space feel welcoming and cozy and integrating contemporary living spaces in the lower level, with traditional formal spaces on the main floor. "We achieved this through the use of vividly colored unique fabrics, while keeping background finishes consistent throughout the home. This provided the clients with the warmth and functionality they were looking for."

"Meeting the needs of our clients is paramount," Cohen and Segel say. "We live and breathe our projects and are totally invested in making our clients' dreams a reality."

ABOVE
The dining room upholstery was selected to bring this antique Persian rug to life. Expansive wood planked table, coffered ceilings, and Venetian-plastered walls create a dramatic space.
Photograph by Beth Singer

LEFT
Lower Level Entertainment Area. Strong color hues integrated with natural finishes and rich upholstery create a warm and inviting gathering space for friends and family.
Photograph by Beth Singer

INNOVATIVE INTERIORS, INC.
Arlene Cohen, ASID
Robbie Segel, Allied Member ASID
5745 West Maple Road, Suite 213
West Bloomfield, MI 48322
248.737.9680
www.myinnovativeinterior.com

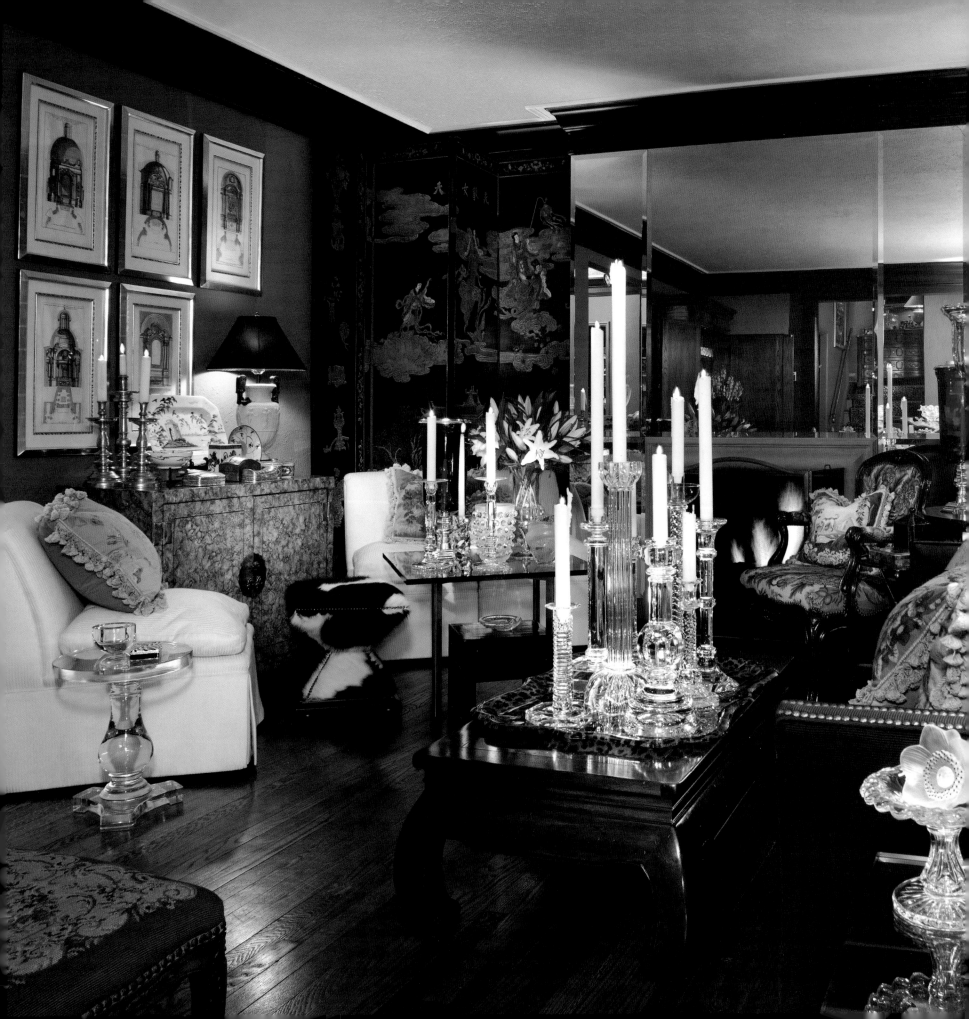

BRIAN
CLAY COLLINS

BRIAN COLLINS INTERIOR DESIGN

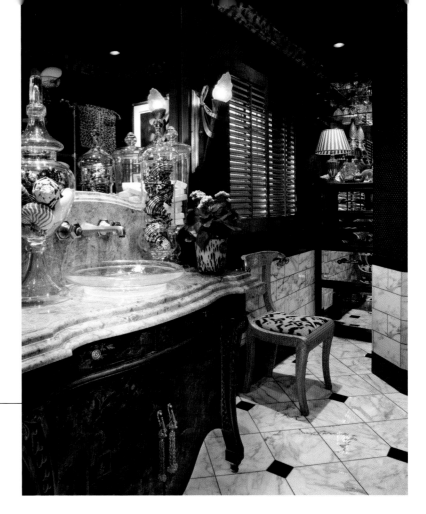

As a fellow of the American Society of Interior Designers, Brian Clay Collins shares an achievement with only three other design professionals in the state of Michigan and about 200 nationwide. The highest membership level that can be attained in the society, it is achieved by nomination and based on professional experience and contributions to the society and the community at large.

"It's quite an honor," says Collins. "I've been involved with the organization on a national and state level throughout my career."

The frequent award winner has been president of the state chapter, served on the national board of directors and served as professional liaison to the national student council, which involved working with up-and-coming designers around the country. He has also served as national chairman for the ASID professional development program, which he characterizes as continuing education for designers.

Collins has also been active with CIDR, Coalition for Interior Design Registration, which seeks licensing for interior designers in Michigan. He's also one of the few designers in the state who has passed the National Council for Interior Design

Qualification exam. NCIDQ is a national testing body for interior design practitioners. Its purpose is to certify designers nationally, allowing the public to find the right professional for their project.

Collins also volunteers time toward the historic preservation efforts for the campus buildings of the Bay View Association of the United Methodist Church, a national historic landmark community on Little Traverse Bay near Petoskey. Founded in 1875, it incorporates some 450 summer homes built between 1875 and the 1920s. "It's a pretty significant community and one of just 13 remaining Chautauqua communities in the nation," says Collins. Others include Council Bluffs, Martha's Vineyard, Chautauqua, New York, and more.

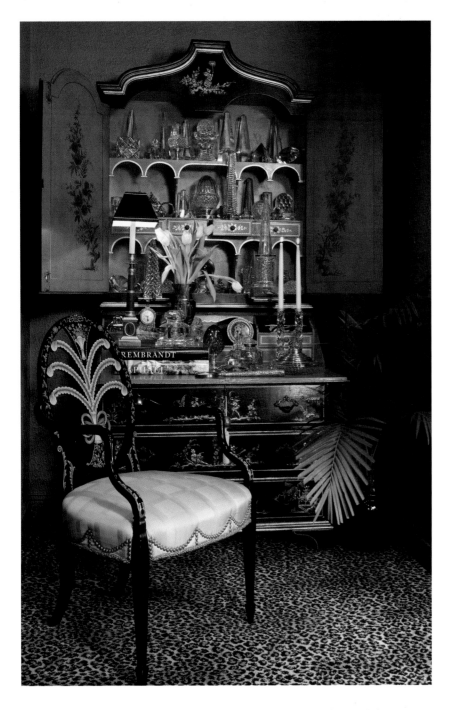

With all of his professional and charity work, it's amazing Collins still has time to work with clients. During his more than 30 years in design, he has become known for traditional interiors with a twist. He gravitates toward strong neutrals and black and white accents for drama, punctuation and crispness.

"My style could be described as classic," he says. "It's not faddish or trendy and will age well. I do like the unexpected. Just as in landscaping, assembling a wardrobe or a menu, it's the mix that makes it memorable."

ABOVE LEFT
In a hallway alcove, this stunning chinoiserie secretary showcases favorite crystal Objet D'Art.
Photograph by Beth Singer

ABOVE RIGHT
Here, sparkling crystal and mercury glass pieces juxtaposed with needle pointe, linen, lacquer and polished wood to great effect.
Photograph by Beth Singer

FACING PAGE
A previously unused attic space has been transformed into a vibrant third floor master bedroom retreat.
Photograph by Beth Singer

MORE ABOUT BRIAN...

HOW HE GOT HIS START IN DESIGN:

As a boy, I'd doodle floor plans on shirt boards and often moved the basement furniture into new room arrangements, even though there were no interior walls.

WHEN NOT WORKING, I...

Love nothing more than reading in a quiet room, preferably with a water view, in a comfortable chair, while listening to good background music. I also love a fire in the grate.

FAVORITE DESIGN ERA?

While appreciating classic 18th-century English and French design, my favorite era is now. We, today, have such broad freedom in creating pleasing, successful interiors, drawing on the best of the near and distant past as well as the present. What could be more stimulating?

SOMETHING YOU'D NEVER USE IN A ROOM?

While disliking absolutes, I cannot imagine ever suggesting an aquarium in a room. I do, however, always prefer fresh, living or dried natural foliage to faux silk arrangements.

NO ROOM IS COMPLETE WITHOUT...

An interesting variety of incandescent lighting. That might include uplights, downlights, cabinet lighting, art lights as well as task lighting. Multiple circuits and rheostats will provide the most flexibility in creating a variety of pleasing lighting moods.

Photograph by Mary Ann Ismal

BRIAN COLLINS INTERIOR DESIGN
Brian Clay Collins, FASID
494 St. Clair Avenue
Grosse Pointe, MI 48230
248.443.6131

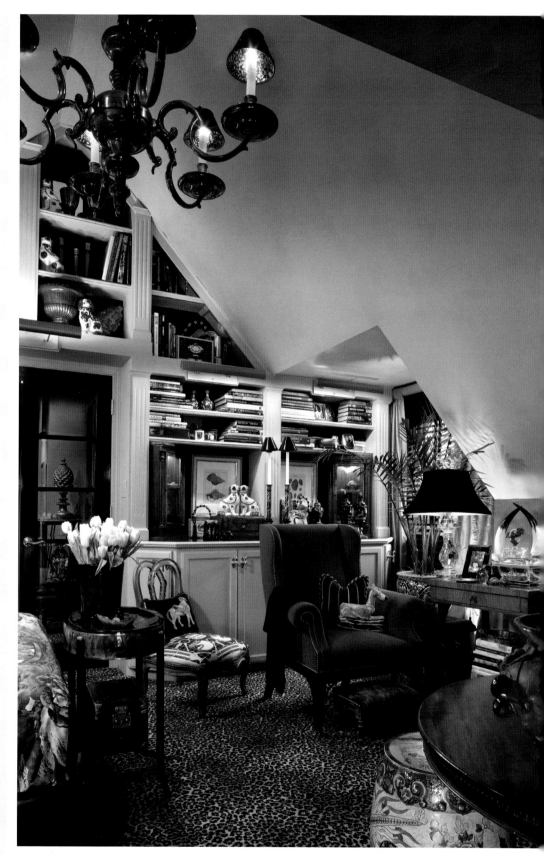

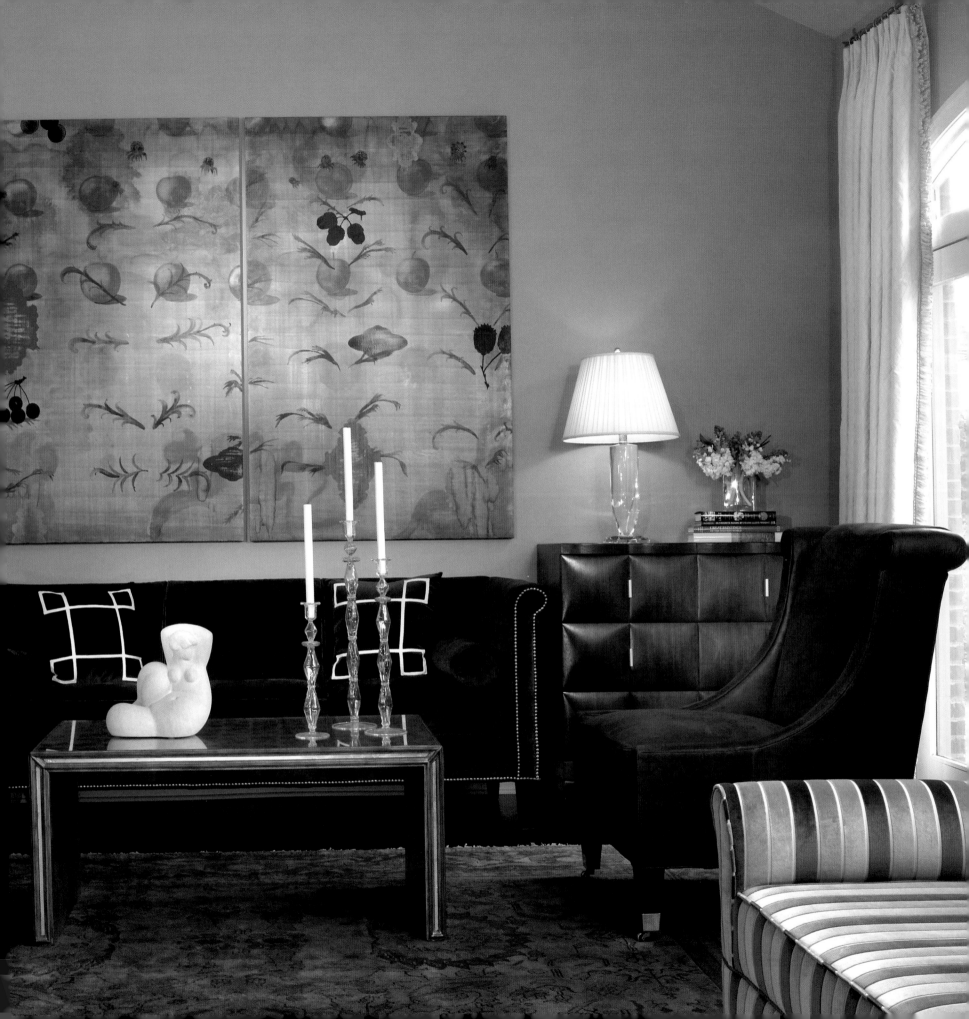

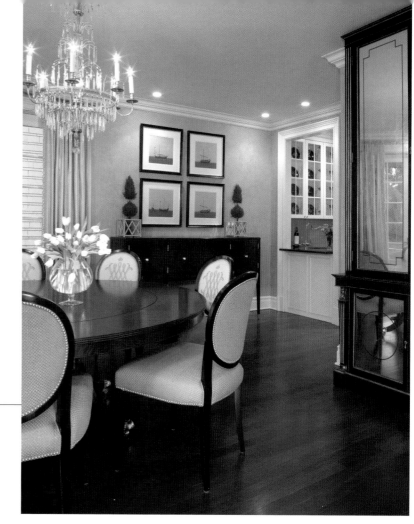

LUCY EARL &
NICOLE WITHERS

JONES-KEENA & CO.

For Lucy Earl and Nicole Withers, design is a family affair. Together, the mother-daughter team own Jones-Keena, one of Birmingham's most recognized and best respected design firms.

Lucy Earl has been a designer in Birmingham and Grosse Pointe for more than 30 years.

"I grew up helping my mom in the business," says Nicole, who eventually went to the University of Michigan and graduated with an anthropology degree. The design business eventually pulled her in, and the pair became partners in 2002, the same year they opened a 4,000-square-foot showroom/retail space. The showroom showcases art, antiques and accessories.

"We wanted to show our clients different things and to give them the opportunity to touch, see and feel them in a room-like setting," says Nicole. "We believe that art is a very important part of an interior, and also wanted a space where we could show off art and antiques."

Their business is successful because their personalities and talents complement each other, says Nicole. While they have their own clients, they brainstorm and confer often. "My mom is a wonderful teacher and a great inspiration," says Nicole. "For me, it's the best part of working together." Their work has been recognized in *Style, Décor, Hour Detroit* and other local and national publications.

Nicole characterizes the firm's style as one of classic timeless interiors, whether they're contemporary or traditional. "All great rooms need to stand the test of time," she says. Both partners also share a love of unusual spaces. "I'd love to design a Buddhist monastery," says Nicole. "The idea of a space that's pared down to the basics is very appealing."

ABOVE
A dramatic mirrored-front bibliotheque adds to the glamour of this dining room.
Photograph by Beth Singer

LEFT
A living room that is both understated and elegant reflects the clients' interests in both paintings and sculpture.
Photograph by Beth Singer

JONES-KEENA & CO.
Lucy Earl
Nicole Withers
2292 Cole Street
Birmingham, MI 48009
248.644.7515

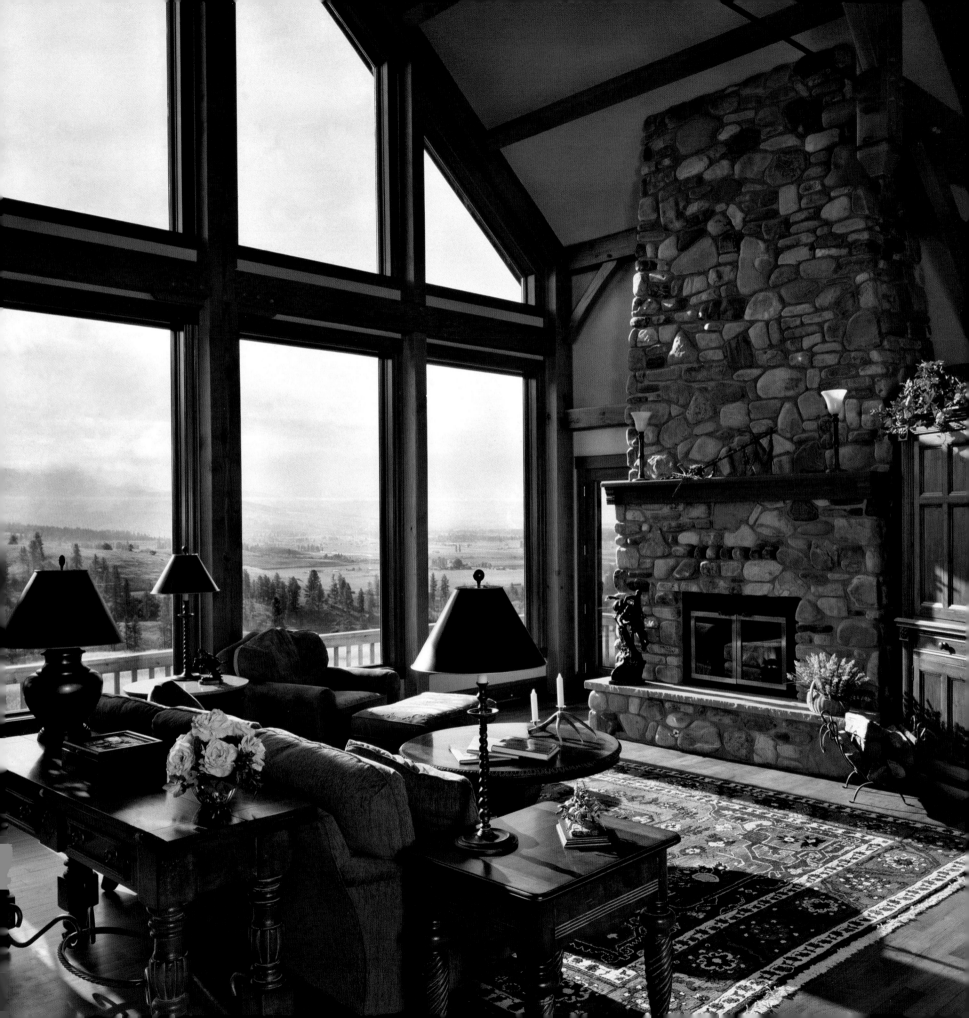

KATHLEEN EMIG
CEDAR CREEK INTERIORS

Kathleen Emig of Cedar Creek Interiors began her career assisting the design staff on her family's fine furnishings business. While she designs homes and interiors across the nation, her love of the Great Lakes prompted the opening of Cedar Creek Interiors, the first professional design firm and showroom in the area dedicated to the "Northern Michigan Lifestyle."

Kathleen focuses on cottage, cabin, lodge, Adirondack, and western-style design. Using natural materials, colors and textures, she meshes her clients' needs with their environment, style and budget.

Spending years as a custom woodworker, kitchen and bath designer, log home designer and general contractor has given Kathleen multi-faceted experience, allowing her to offer clients a collection of experience and knowledge in one person.

In a recent visit to a home she had designed and built 15 years earlier, Kathleen found nothing had changed, not an accessory moved.

"Sitting in front of a client's crackling fireplace in a home I designed, built and furnished, the owner turned to me and said, 'After all the years and all the houses we've had, for the first time, we are really home.' That's the best compliment I've ever received."

ABOVE
Warm timber frame foyer with natural woods and rich reds.
Photograph by Roger Wade

LEFT
Home Design—Kathleen M. Emig, Bear Creek Timberwrights—timber framing, Hickory White case goods, Large Mountain Valley vistas with Montana Honey Rock Fireplace.
Photograph by Roger Wade

CEDAR CREEK INTERIORS
Kathleen Emig
275 East Main Street
Harbor Springs, MI 49740
231.526.9026
Fax: 231.526.5795
www.cedarcreekcollection.com

MARY JANE FABIANO

SAMUEL DESIGNS, INC.

Mary Jane Fabiano loves most of the rooms she designs, but she's happiest, perhaps, with a bedroom she recently completed for her grandson, Samuel.

The Grand Rapids-area designer has done a variety of rooms for the 15-year-old since he was little. She even named her company after him.

"When I was searching for a name for my business 15 years ago, I knew it had to be a name that was special to me. Samuel Designs is named after my first grandson, Samuel Fabiano."

Sam's room has changed through the years and currently is a sophisticated study in lime green and black.

After talking to Fabiano, it's clear that friends and family come first.

"I feel my friendliness and sincerity shows through when I meet with clients. I tend to turn clients into friends," she says.

Fabiano's favorite rooms are rich and classic she says with liberal doses of black. She also likes soft contemporary homes filled with clean lines and warm colors.

"I like rich taupes and blacks. I also like chocolates and blue and other color schemes that never go out of style," she says.

While she loved working on her grandson's room, she says one of her most rewarding projects was a house she recently completed in Kalamazoo, Michigan, owned by Marc and Heather DeForest. "I took a 12,000-square-foot 'white box' and transformed it into the beautiful home displayed in this book," says Fabiano.

ABOVE
The formal foyer features cherry wood handrail and a striking chandelier. Faux wall painting, with gold-leaf painted squares, creates an elegant yet warm entry way which affords glimpses into adjoining rooms as one begins to absorb the sense of design throughout.
Photograph by David Leale

LEFT
The formal dining room has a classic, sophisticated look, yet design is kept simple. Subtle, textured tones in beiges and mustards with touches of black are offset by high-end Baker furniture with custom upholsteries done in natural silks.
Photograph by David Leale

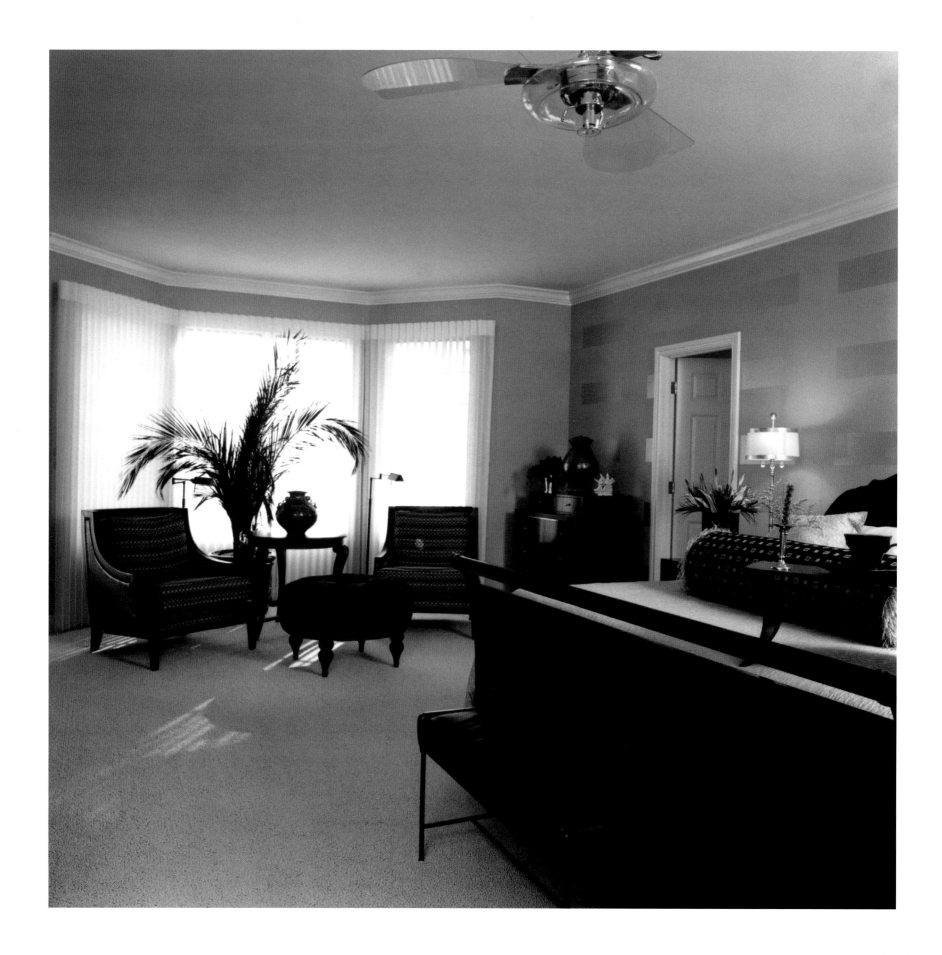

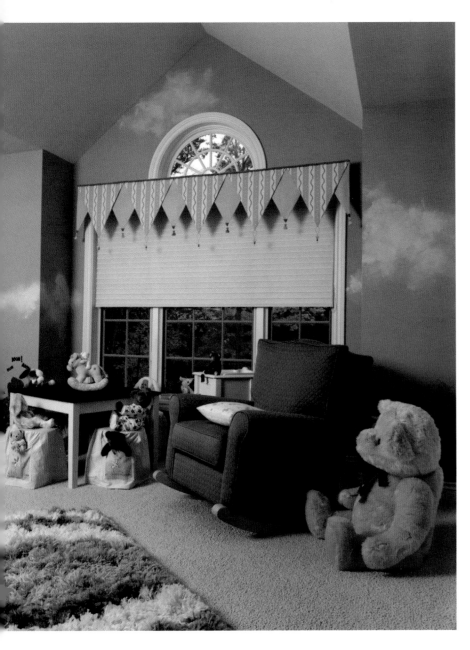
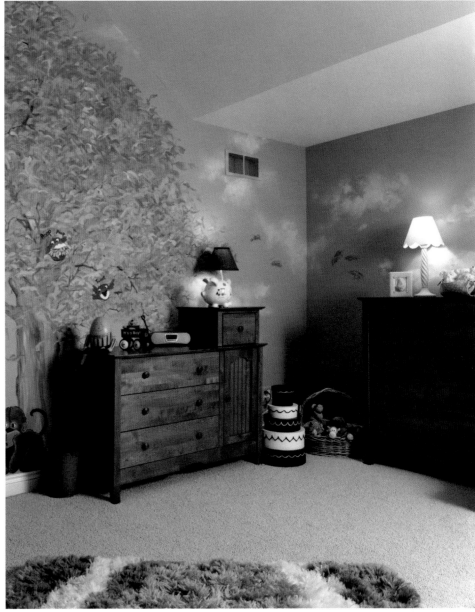

"When I finished the DeForest's Michigan home, they sent me to decorate their Las Vegas home. Also, my daughter, Laura Fabiano, is a commissioned artist and we work together a lot. Every piece of art in these two homes was done by her. It doesn't get any better than that."

When she's not working, Fabiano enjoys spending time with family and going to dinner with friends. She also enjoys her three cats, including her exotic Bengal. One day she'd like to volunteer her time at an animal shelter.

For now, she's busy keeping up with her thriving design business. Fabiano has never advertised and finds most of her clients through referrals or word of mouth.

"Completing a beautiful project and having happy clients is so rewarding," she says. "I prefer residential over commercial work because I have contact with the people. I also prefer renovations and redos over new construction because they're more of a challenge. I love looking at a particularly difficult project and figuring out how to fix it. The best part is when you're finished and you go back. You feel great. The clients are happy, you're happy and there's a real sense of satisfaction. Every day in this business is exciting. It's always something different."

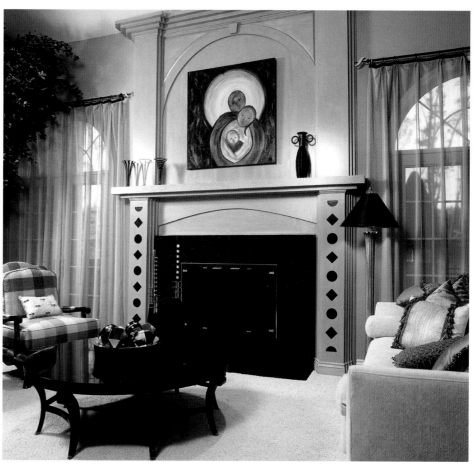

FACING PAGE LEFT & RIGHT
The nursery features whimsical wall paintings of an idyllic nature including skies filled with clouds, trees and frogs, complementing the overall "teddy bear" theme. Custom-made window treatments add flair to the very pleasant baby-blue hue, creating a relaxed atmosphere for baby and all.
Photograph by David Leale

TOP RIGHT
The formal living room with cathedral ceiling features a custom-built beech wood mantle, highlighted by granite, and includes one of the specially-commissioned art pieces by Mary Jane's daughter, Laura, which symbolizes the owner's family. High-sheen cocktail table in ebony and all-silk Baker and Kravet furniture define elegance and comfort in this highly livable area.
Photograph by David Leale

BOTTOM RIGHT
Heather's personal study is decorated with neutral, but contemporary furniture. The animal-print faux painting, which covers the walls, gives the feel of an African safari hideaway.
Photograph by David Leale

MORE ABOUT
MARY JANE...

WHAT PERSONAL INDULGENCE DO YOU SPEND THE MOST MONEY ON?

Jewelry.

WHAT BOOK ARE YOU READING RIGHT NOW?

The Da Vinci Code by Dan Brown.

WHAT IS A SINGLE THING YOU WOULD DO TO BRING A DULL HOUSE TO LIFE?

Paint!

HOW MARY JANE GOT STARTED AS AN INTERIOR DESIGNER:

Worked as a gopher for another local interior designer. Started "monkeying around" with design when she bought her first home. Turned to a career in design after her third child went to school. Trained at a design school in Chicago and through a correspondence course, I discovered I absolutely loved it. I've never regretted it for a minute.

SAMUEL DESIGNS, INC.
Mary Jane Fabiano
6629 Denham Court SE
Grand Rapids, MI 49546
616.676.1685
Fax: 616.676.3353

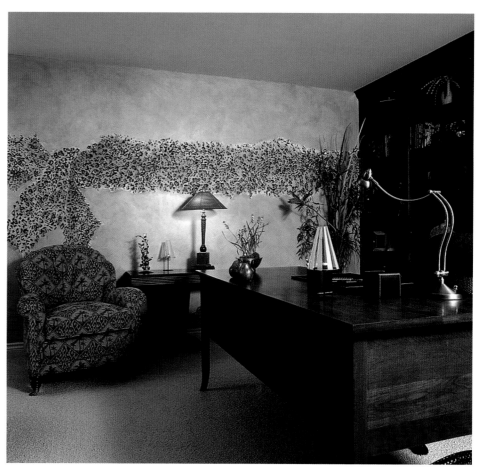

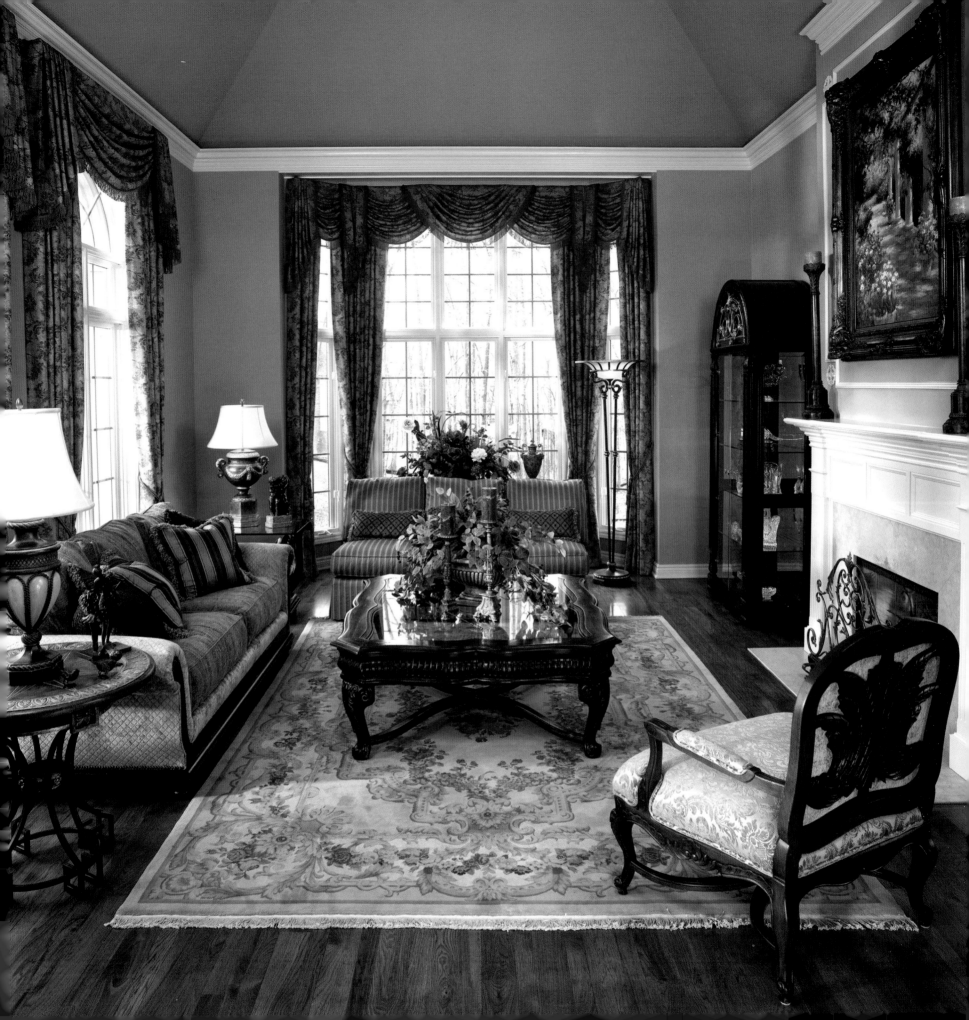

MICHAEL FORAN

MICHAEL FORAN INTERIORS

Michael Foran Interiors is a high-end interior design studio with professional designers who really care about their clients and their clients' homes. They complete a home or room using a client's personal style as well as exact detailing, comfortable furnishings and items from fine quality companies.

Design services include working with floor plans, furniture and accessories, new construction or remodeling, custom window treatments, architectural detailing, space planning, flooring, lighting and more.

Through the years Foran and his associates have developed a series of questions that help them capture each client's personal style. This enables them to provide each client with a beautiful environment that is truly tailored to his or her individual taste.

Whatever the project, be it wall treatments, architectural elements of moldings, ceilings or fireplace surrounds, Foran Interiors focuses on the details. Their talent, experience, and attention to detail results in a home that is a comfortable and relaxing retreat.

Foran's downtown showroom has many large photographs of beautiful rooms that he has completed. Visit the 3,000-square-foot showroom to see a sample of what they do and learn more about their motto: "By using our design service, you will save time and avoid costly mistakes."

ABOVE & LEFT
Michael Foran has helped us design a home that is equal parts comfort, beauty and elegance. He took our personal style and vision and expanded it to exceed our expectations.–Robert and Toni
Photographs by Alan Davidson Photography

MICHAEL FORAN INTERIORS
Michael Foran ASID, NCIDQ
313 South Main Street
Rochester, MI 48307
248.601.2007

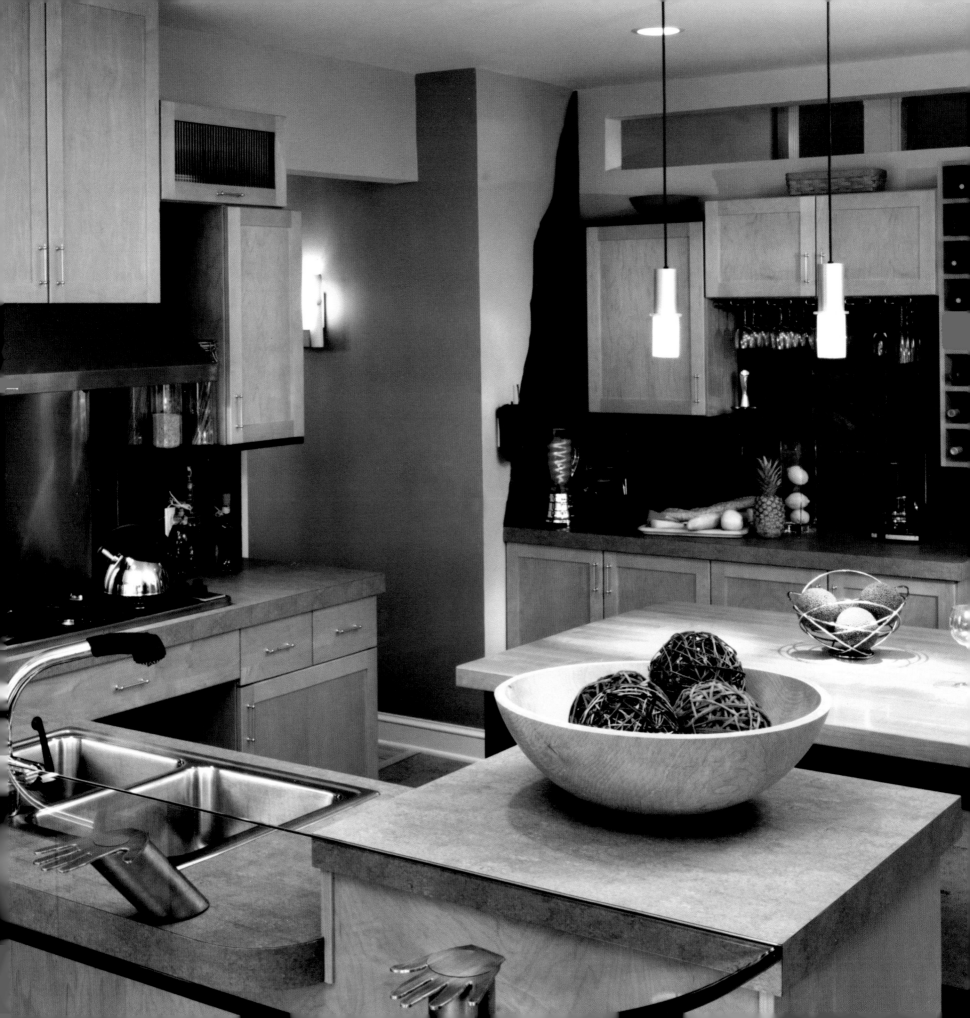

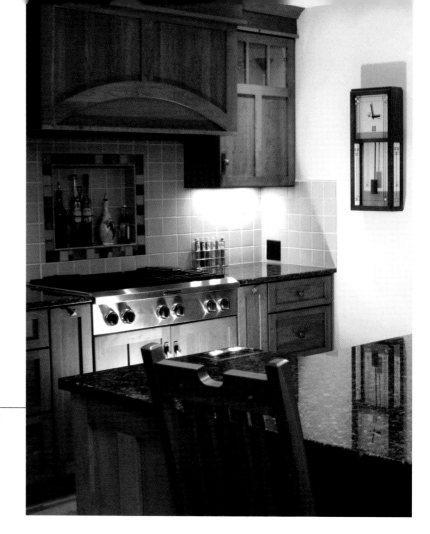

MARY GREINER-KEISER

DWELLING CONCEPTS LLC

Mary Greiner-Keiser is lucky enough to live and work along the shores of Lake Michigan. She attended Grand Rapids Kendall College of Art and Design and brings that artistic sensibility to everything she does. "Kendall is the Juilliard of Michigan," she insists. "It has definitely given me a creative edge."

Mary has been a practicing designer since 1994. She worked for eight years for a variety of kitchen and bath design shops. She left to form her own business, Dwelling Concepts, in 2001.

"I enjoy being part of the overall design process, which is the reason I founded Dwelling Concepts," she says. "I wanted to fill a need I saw time and time again…to fully service the client by helping them dream, plan, budget and develop their entire home including how rooms relate, controlled traffic flow, storage needs, furniture requirements, lighting necessities, functional fabric selections brought together by a harmonious color scheme," she says. "Sound home design has to include the kitchen, but not just be about the kitchen. I believe it is truly a privilege to design someone's personal space where they love the people dearest to them and create lasting memories; therefore I can't just sell a kitchen or bath job and have peace with the service I offered."

ABOVE
Craftsman in style, designed to entertain with a 36" high hard-working center island which can either be an all-around access buffet table during large gatherings or used as a multi-functional surface for everyday activities. Completing this highly effective kitchen layout is a mix of custom cherry and maple cabinetry, walk-in pantry, host station, built-in wrap around bench for additional seating, granite counters and stainless appliances.
Photograph by Marc A. Hoeksema

LEFT
This contemporary styled kitchen was designed with standard-size cabinetry hung in an unconventional way for the look of custom without the costly modifications. Adding to the flair, hand tracings were made of the family and used to fashion templates for the stainless hands that support the glass countertop seating area. Completing this fun space is a mix of concrete, maple and chunky laminate countertops, custom center island, maple cabinetry with a pear wood finish, walk-in pantry and a 72" high stainless tambour storage area.
Photograph by Bill Hebert

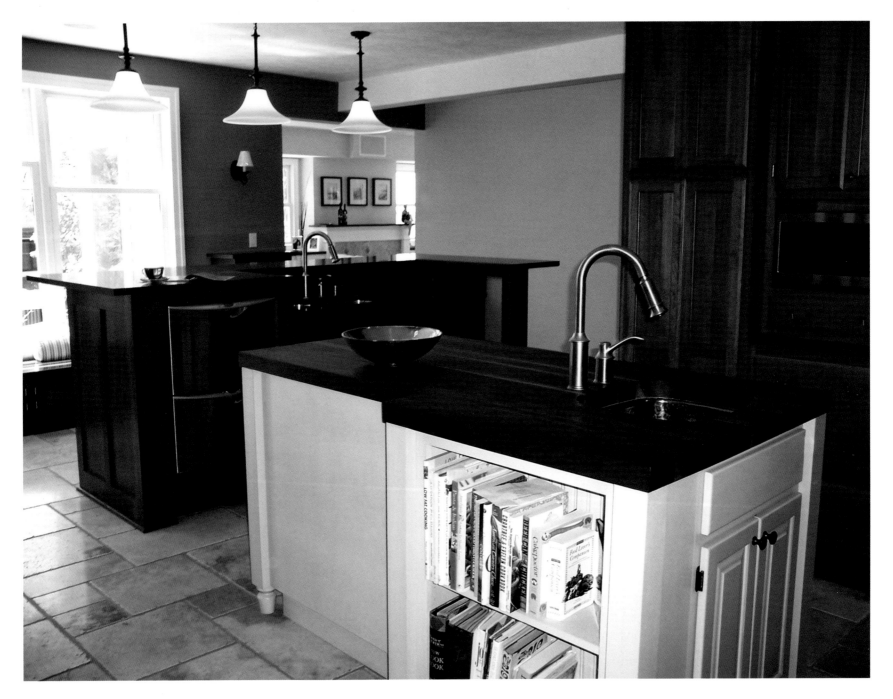

She works mainly in nearby Spring Lake, Grand Haven and North Muskegon with a solid team of experienced professionals. "I work with a lot of amazing talent," Mary says. "My key players are Bryan Laud, my conscientious contractor; Phyllis Howard, my lighting specialist; Tony Martinez, my glass guru; Morgan Dowsett, my hardware aficionado; and Anthony Robbins, my inspiration coach. We share dedication to excellence with a results-focused outcome. It sincerely is my pleasure and privilege to work with them."

"I love the multifaceted business of interior design," she continues. "Contrary to popular belief, this work is not glamorous, but it is fun. Remodels are my favorite, because they're always an adventure," Mary says. "New construction is fun, but it is less challenging overall."

"My goal for every project is to work creatively with my clients to build their home, bring joy to the process and never just fill space," she says. "Years later, I still get postcards from clients who say they love living in the homes we created together. Now that's rewarding."

MORE ABOUT MARY...

WHAT SEPARATES YOU FROM THE COMPETITION?

My passion for this work and creativity, selling approach, excellent products, the talented individuals I work with and the level of service we offer and that we are committed to giving to each other and to the client.

WHAT IS YOUR SELLING APPROACH AND DESIGN THEORY?

Competing in this business is what non-creative companies do. The rest of us just create exciting spaces that make sense and the selling takes care of itself based on three key factors: budget, layout and the level of aesthetic details the client desires.

WHAT IS YOUR PERSONAL STYLE?

Smart, creative design always wins with me regardless of style preference, but I do favor a minimalist approach that weeds out clutter and showcases the effects of light on the architecture is found in contemporary design.

WHAT EXCITES YOU ABOUT BEING PART OF SPECTACULAR HOMES:

Being among such an elite group of designers in an artfully displayed body of work.

Photograph by Marc A. Hoeksema

DWELLING CONCEPTS LLC
Mary Greiner-Keiser
1110 Mills Avenue
North Muskegon, MI 49445
231.744.7123
www.dwellingconcepts.net

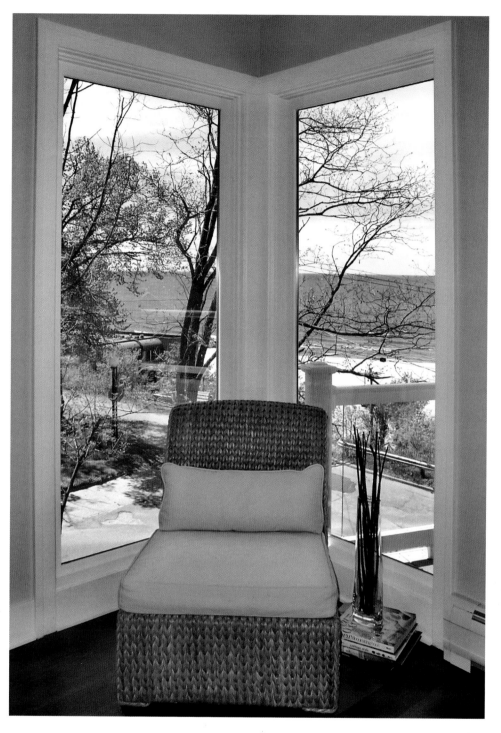

ABOVE
This hilltop home has one of many excellent views of Lake Michigan for my client to enjoy for years to come.
Photograph by Samantha Jo Greiner

FACING PAGE
The layers of color throughout this beachfront home draw you in, but the views and cozy inviting spaces keep you. This kitchen is filled with wonderful appliances that make meal preparation easy and fun. The outer island seating keeps guests close to the cook for visiting and the furniture center island is a great spot to add a cook's helper.
Photograph by Samantha Jo Greiner

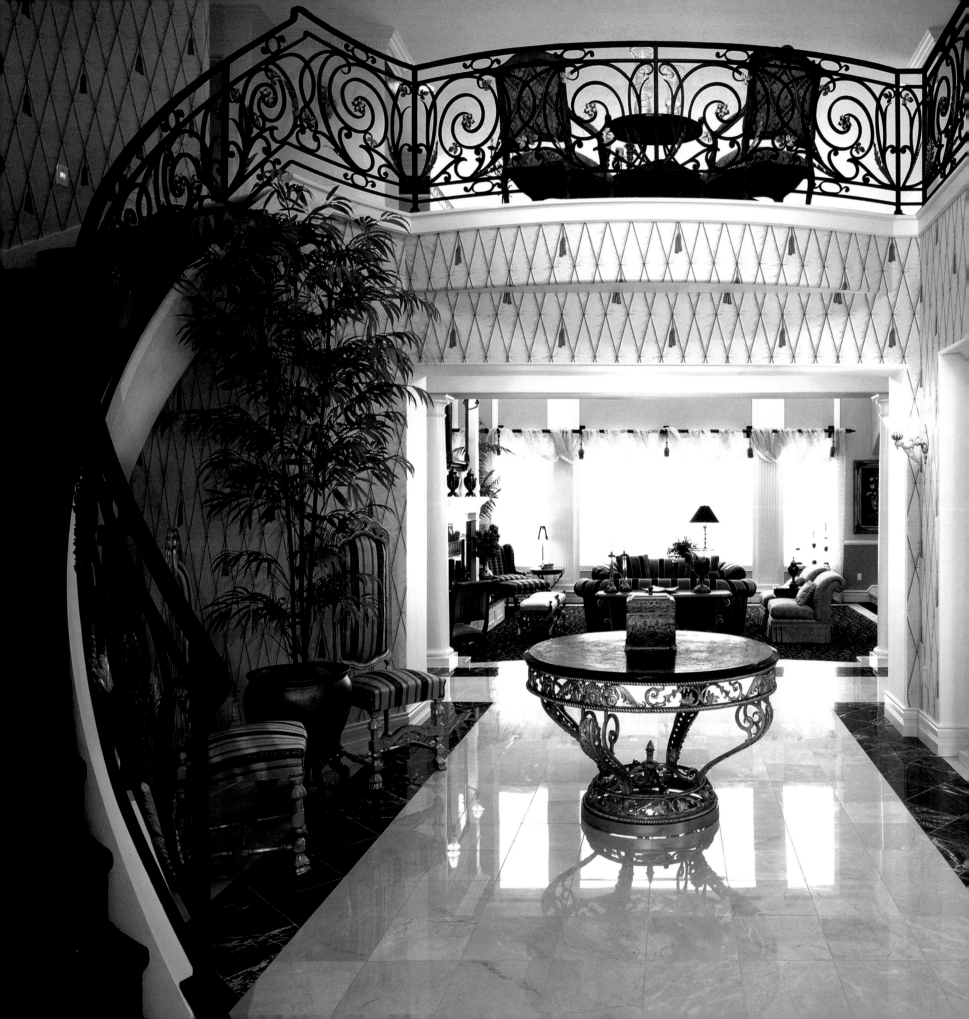

RENEE GUTHRIE

LAKE STREET DESIGN STUDIO

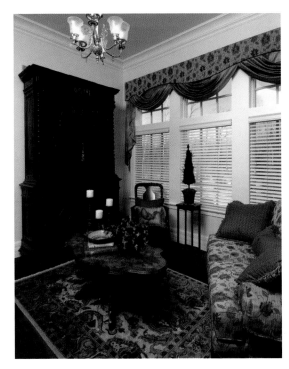

Petoskey interior designer Renee Guthrie creates warm, inviting spaces based on classic design principles. Renee is constantly expanding her vision through travel and study and her designs often reflect French and European influences. "If you stick with the classics, you'll never go wrong," she says.

Through her studies at Michigan State, Renee discovered early on that the inspiring and artistic world of interior design provided an avenue for her to express herself. Twenty years later, Renee stills says, "I feel blessed and excited to have work I absolutely love."

Renee's design work won awards in the NKBA's design competition in 2002. She was also featured in the January/February 2003 issue of *Northern Home Magazine* and the March/April 2006 *Northern Home & Cottage* magazine Her clients are from Detroit to the Upper Peninsula, Florida and beyond. Renee's design business is located in Petoskey's Gaslight District at the Lake Street Design Studio, which she shares with her staff of talented interior designers and kitchen designer Dawn Whyte. Together they offer a unique, relaxed atmosphere where clients can select finishing elements for every space in their home. I really enjoy spending time with each of my clients," Renee says. "My ultimate goal is happy clients with beautiful rooms."

ABOVE
Renee incorporated her clients' love of dark ornately carved furnishings and other antiques from around the world into a quiet comfortable place to relax.
Photograph by Michael W. Gullon

LEFT
Renee created this home to reflect the grand homes that her clients had visited throughout the world. The finishing elements were all selected to express French and Far Eastern influences.
Photograph by Michael W. Gullon

LAKE STREET DESIGN STUDIO
Renee Guthrie
224 Park Avenue
Petoskey, MI 49770
231.348.1824
Fax: 231.344.6200
www.lakestreetdesignstudio.com

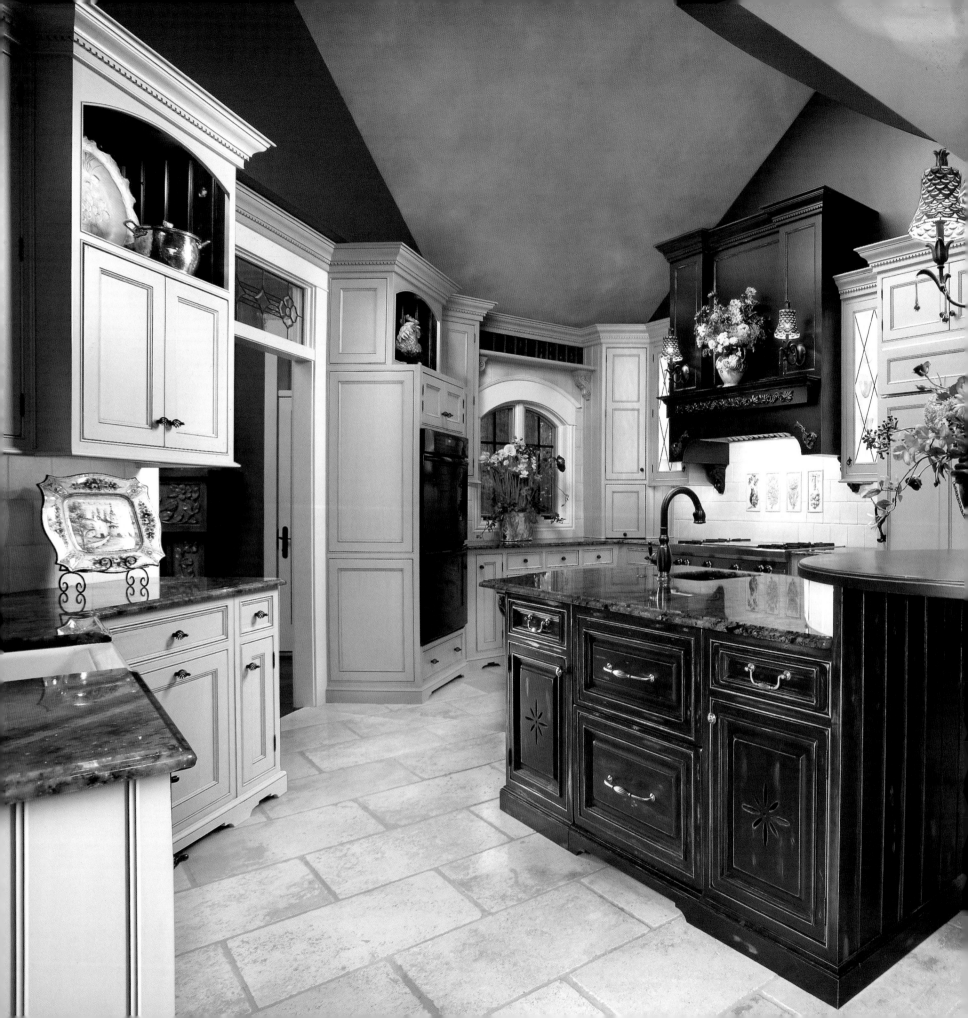

JENNIFER HOLTROP
NANCY OLENDER
RHIANNON CLOW
SPACES UNLIMITED

S paces Unlimited's talented design team consists of Jennifer Holtrop, Nancy Olender and Rhiannon Clow. Each has a specialty that helps them work together more effectively and makes them invaluable to their clients.

"We offer a variety of services not usually found in Grand Rapids under one roof," says Holtrop. "We have full interior design, cabinetry design and interior architecture, which includes things like casework, moldings and other architectural elements.

"We are also very team oriented. We collaborate on every project and each of us knows what piece we're responsible for. As a whole, we offer outstanding customer service and we believe in paying attention to every detail."

Working on a combination of renovations and new house construction has kept the talented trio busy since the start of their business in 2000.

"Renovations and new house construction are both equally challenging and fun projects to work on," says Holtrop.

In December of 2005, Spaces Unlimited was proud to open their new 3,200-square-foot retail space and design showroom in Cascade, an eastern suburb of Grand Rapids. It attracts clients and customers from the greater Grand Rapids and the surrounding lake communities who are looking for anything from accessories to furniture. The showroom also serves as a creative and professional atmosphere in which to meet clients on home renovation or new construction projects.

LEFT
This gothic-inspired home has a beautifully appointed kitchen. The details are executed in every element that makes up this wonderful room.
Photograph by William Hebert

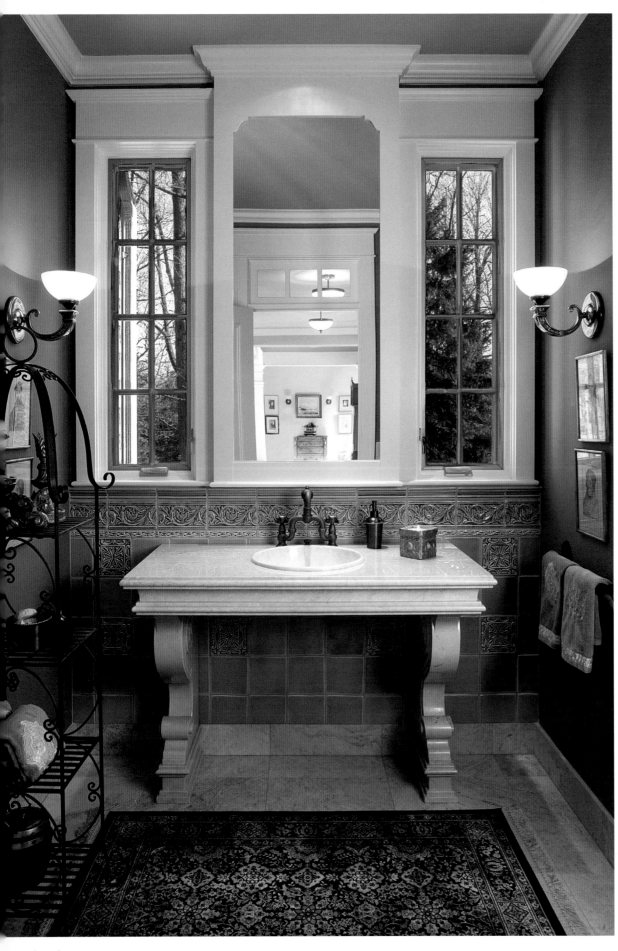

"The showroom really sets us apart," says Holtrop. "It shows all of our offerings, including cabinetry, interiors and home accessories under one roof. We wanted to bring a big city shopping experience like the Chicago Merchandise Mart or the Michigan Design Center to Grand Rapids."

Also found in the new showroom is Spaces Unlimited's newly launched private furniture line, Fusion 2. "Fusion 2 offers custom furniture in every style and for every taste," says Nancy Olender. "The sky's the limit," she says. "Any fabric, color finish or embellishment is at the client's fingertips."

Holtrop says that while many think Grand Rapids is a very conservative area, they've found that the people truly care about having beautifully designed spaces.

"We meet so many wonderful people, it's a pleasure to help them create beautiful spaces she says. "We recently finished a light Gothic style with very unique finishes. It forced us to be very creative."

"We love helping a customer from start to finish," says Holtrop. "To look at their plan from the beginning and see it taken to the end when accessorized, with pictures on the wall, is so rewarding."

LEFT
This powder room is enhanced with natural limestone products and beautifully installed wall and floor tile.
Photograph by William Hebert

FACING PAGE TOP
Through beautifully executed trim details, this room creates an elegance that is grand yet inviting.
Photograph by William Hebert

FACING PAGE BOTTOM
The uniquely colored custom cabinetry, soft hued tiles and gorgeous limestone floors are the foundation to this light and breathtaking room.
Photograph by William Hebert

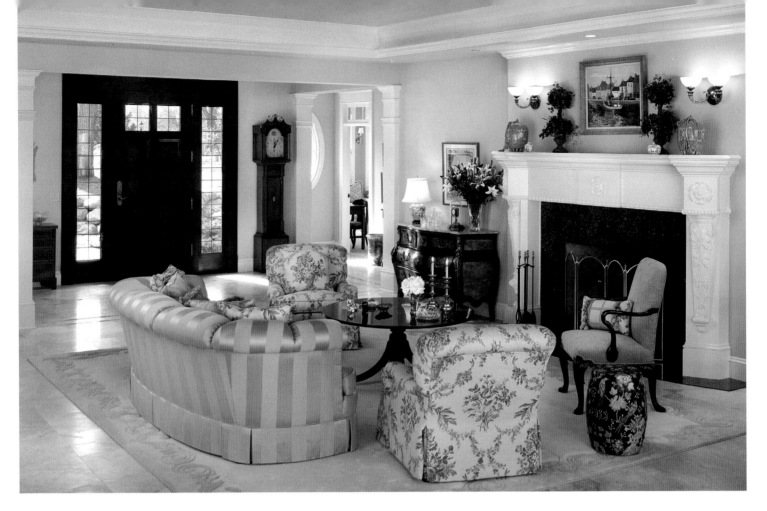

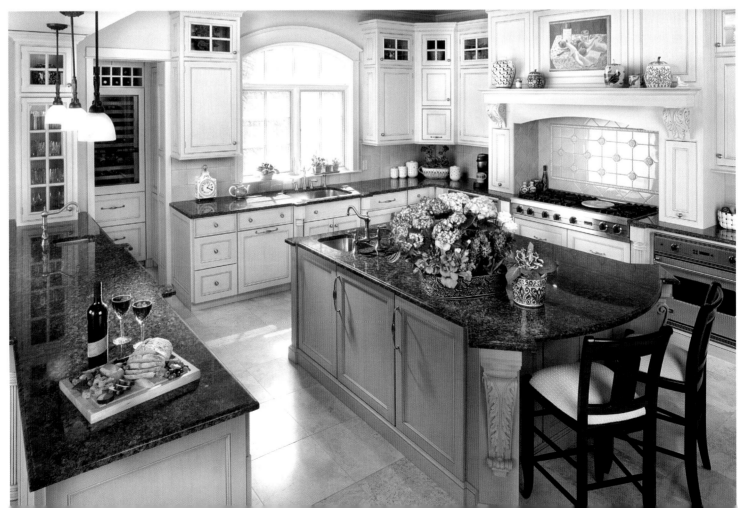

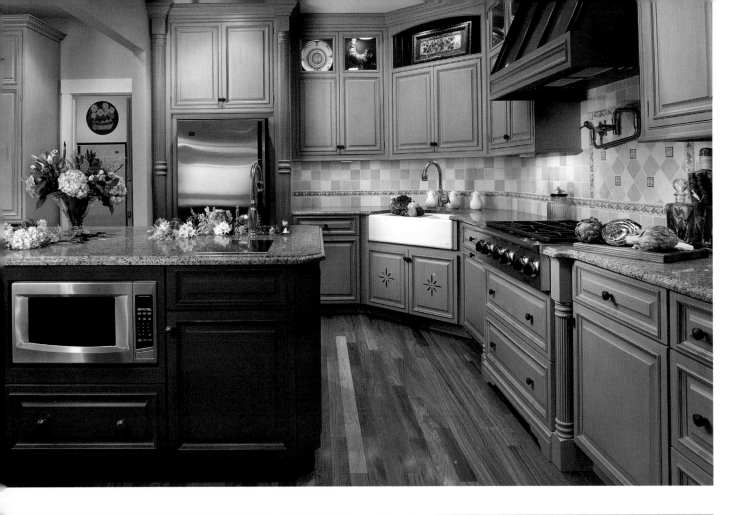

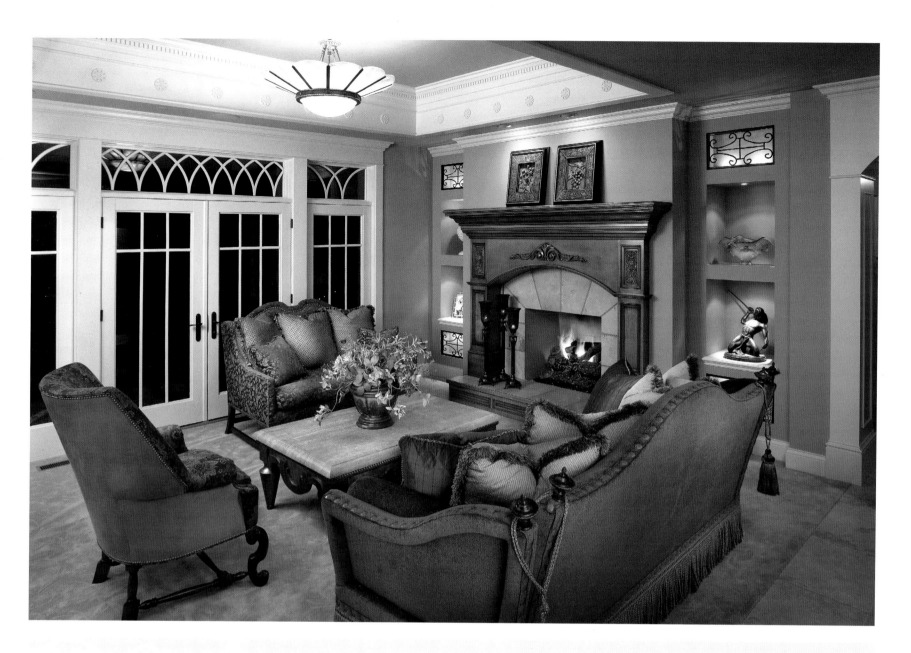

MORE ABOUT JENNIFER, NANCY & RHIANNON...

WHAT IS THE BEST PART OF BEING A DESIGN TEAM?

We get to meet so many wonderful people and help them create beautiful spaces.

WHAT ONE ELEMENT OF STYLE OR PHILOSOPHY HAVE YOU STUCK WITH FOR YEARS THAT STILL WORKS FOR YOU TODAY?

Pay attention to every detail.

WHAT IS A SINGLE THING YOU WOULD DO TO BRING A DULL HOUSE TO LIFE?

Use wonderful paint colors.

IF YOU COULD ELIMINATE ONE DESIGN/ARCHITECTURAL/BUILDING TECHNIQUE OR STYLE FROM THE WORLD, WHAT WOULD IT BE?

We wouldn't—we embrace all types of styles because our clientele varies so much from person to person.

WHAT IS THE HIGHEST COMPLIMENT YOUR DESIGN TEAM HAS RECEIVED PROFESSIONALLY?

That we listen and that we exceed their expectations.

SPACES UNLIMITED
Jennifer Holtrop
Nancy Olender
Rhiannon Clow
5625 Prairie Creek Drive
Caledonia, MI 49316
616.988.5655
Fax: 616.988.5644

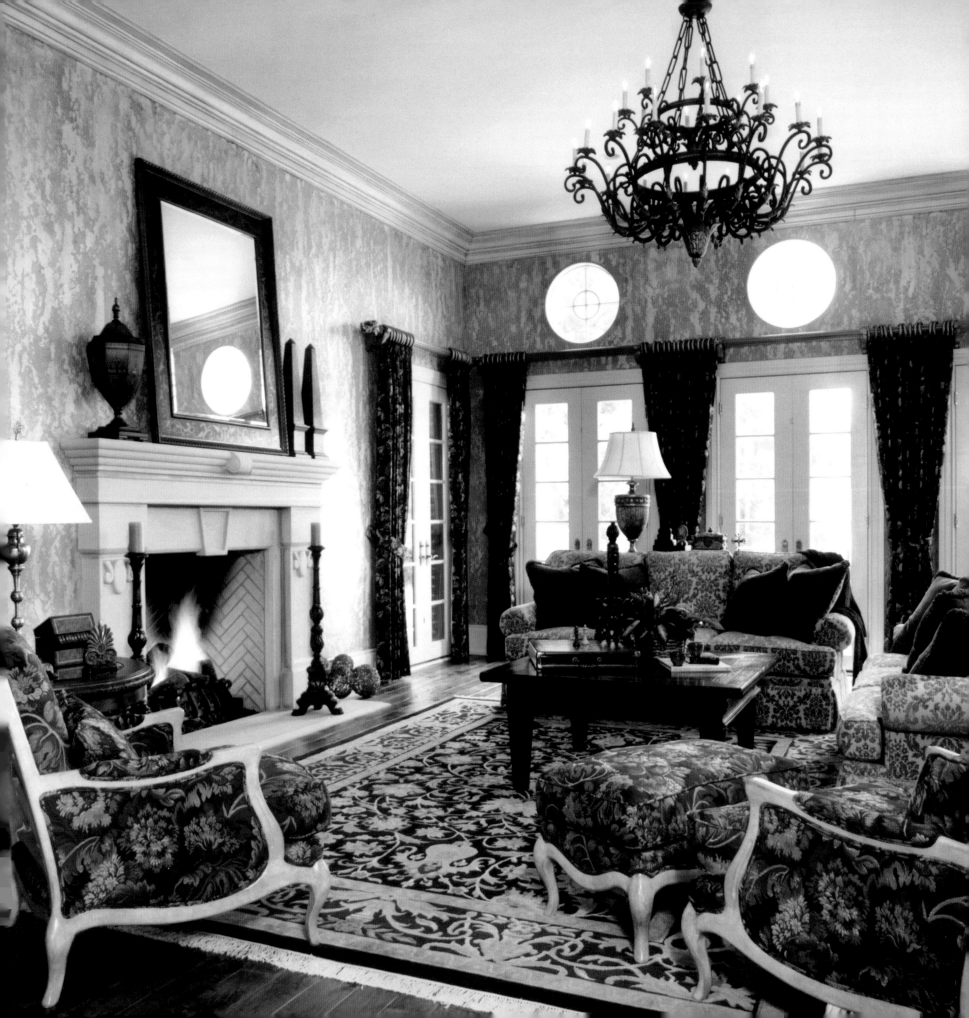

DAVID MICHAEL JOHNS

DMJ INTERIORS

"Classic design is timeless and will never go out of style," states David Michael Johns, owner and president of DMJ Interiors. The Rochester designer has lived by these words with a successful interior design career spanning more than 30 years. With a staff of 11, DMJ interiors has been successful in spite of minimal advertising. "We have an extensive client base and, thanks to them, word of mouth is our main source of advertising," says Johns.

As part of a philosophy of giving back to the community, DMJ Interiors has been involved with a number of charity-run designer showhouses. Johns has worked as showhouse chairperson for a number of them. "Participating in each showhouse is strictly a group effort," he says. "Our design team works well together to make each room become a feast for the eyes."

The design firm is known for their fresh take on classic design. "We also do contemporary very well," says Johns. "I truly believe that any designer can create, but you have to create for the client and not make the client's home a tribute to yourself." Johns is particularly proud of a client's 9,000-square-foot vacation home located on the Caribbean island of Anguilla. "The logistics of it were amazing," he says. "It took three years to complete. We had to use cinder block because of the prevalence of hurricanes and we handled all of the supplies and construction ourselves. The house has 30-foot-tall ceilings and interiors that are very 'Ralph Lauren.' It's a spectacular home."

"Work keeps me sane," says Johns, who is currently working on homes in Rochester Hills, Grosse Pointe, Bloomfield Hills, Clarkston and as far as Florida. "Your home is likely to be the most important investment that you will ever make. When you hire a designer, that individual becomes an added investment in your home. This should be an association based on trust because your designer will work at creating pleasurable surroundings and help make your house your home." Johns and his wife have two children who are pursuing design careers. His daughter works as a designer in Florida and his son is a graphic design student at the College for Creative Studies in Detroit.

TOP LEFT
A Neo-Classic bed, in rich burled woods, is flanked by a pair of chairs upholstered in French silk becoming the perfect companions for the over-stated deep earth-toned walls.
Photograph by Jeff Garland

BOTTOM LEFT
The seating area of this master suite provides nothing but luxurious comfort. Whether your choice is the down-filled chenille sofa or the tufted leather writer's chair, luxury is the main element of this retreat.
Photograph by Jeff Garland

FACING PAGE TOP
This living area, complete with baby grand, is finished using both traditional and transitional pieces which bring a sense of serenity to this room setting.
Photograph by Beth Singer

FACING PAGE BOTTOM
Inlaid mahogany table, ebony finished dining chairs upholstered in French striped silk and dramatic lighting make up this perfect setting for entertaining.
Photograph by Beth Singer

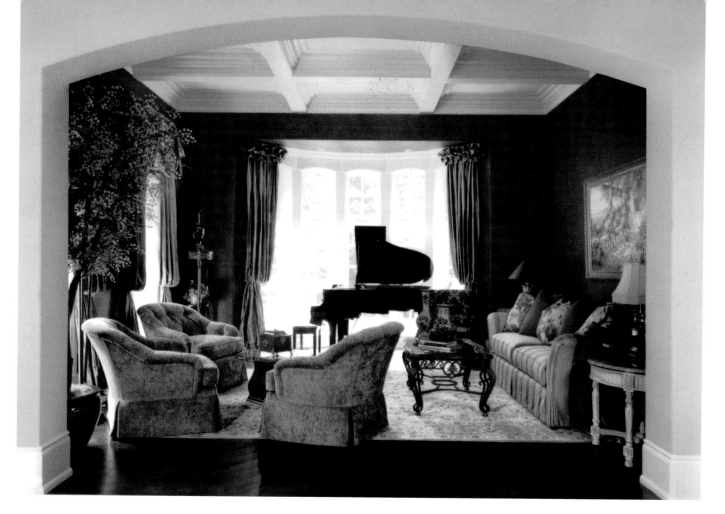

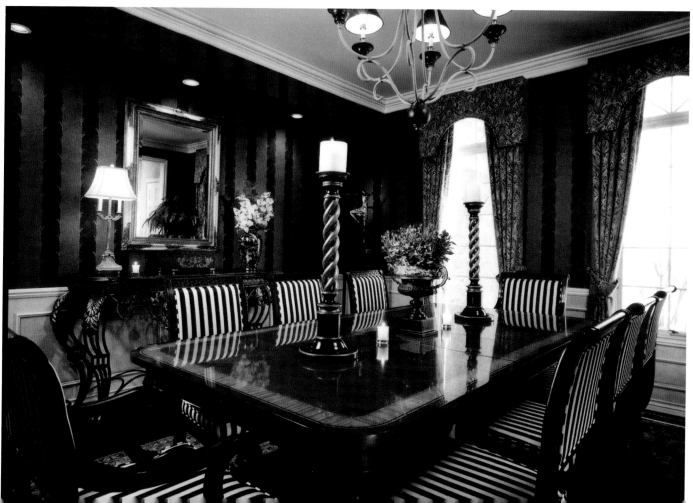

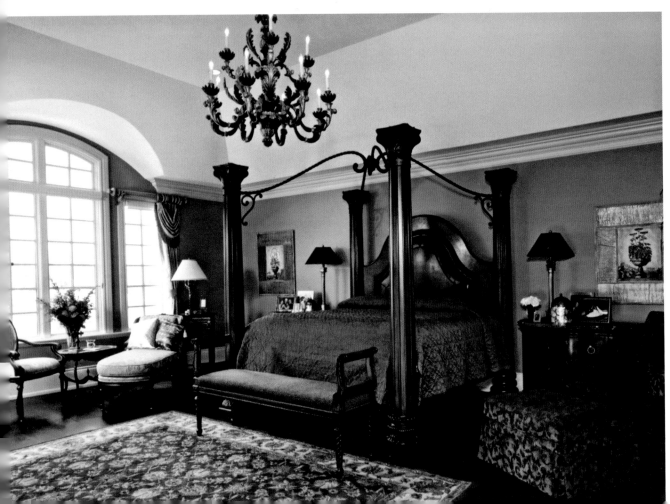

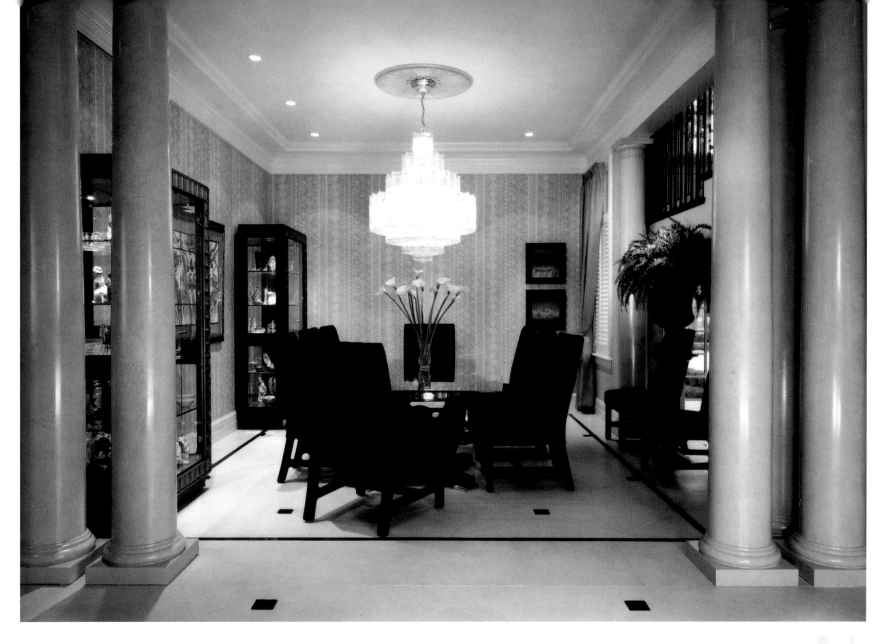

MORE ABOUT DAVID...

The relationship that develops throughout the design process and the personalized attention shown to each patron is something that enhances the end result. I believe that honesty and integrity are synonymous with the most satisfied clients and I find this true through my clients' referrals.

Sweaters, ties and golf.

DMJ INTERIORS
David Michael Johns, IDS
301 Main Street
Rochester, MI 48307
248.650.4900

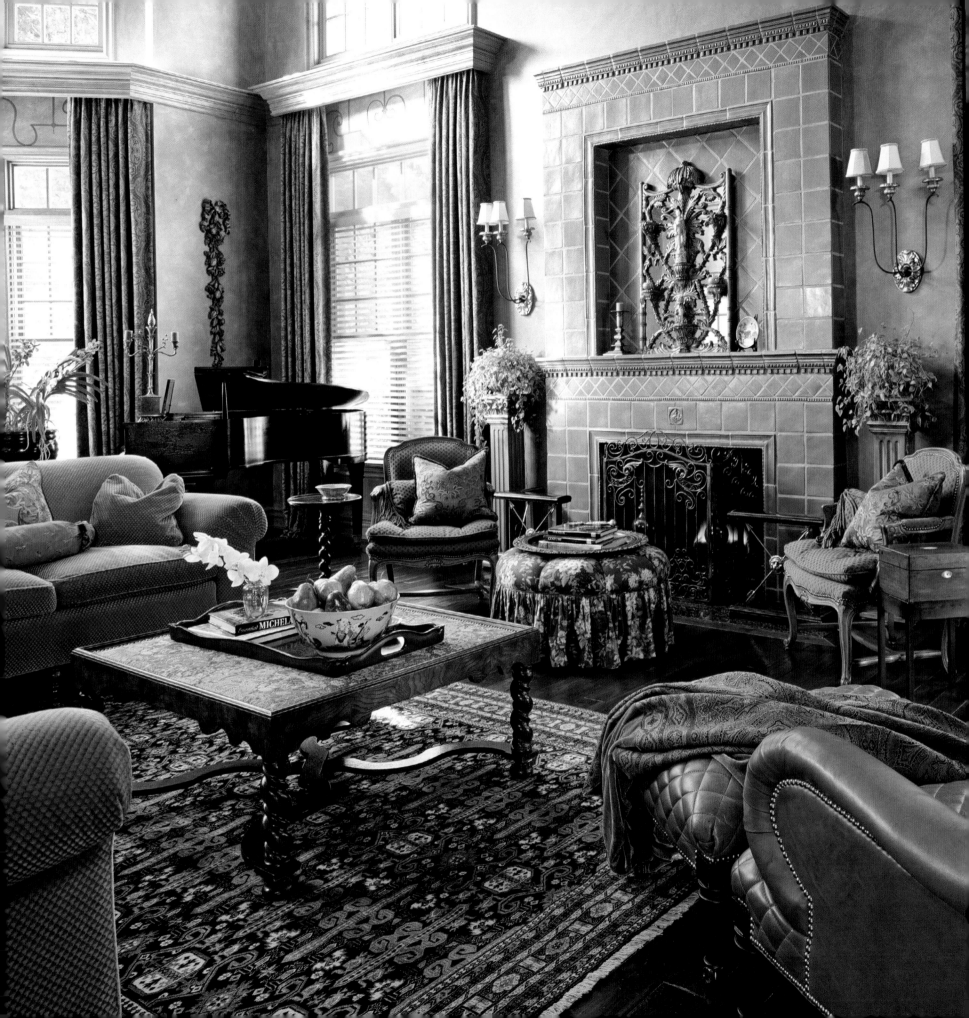

JOSEPHINE
SESI KASSAB

J.S. KASSAB INTERIORS

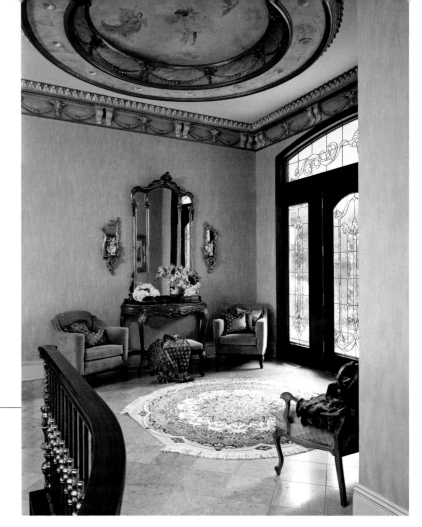

For Josie Kassab, the best part of being an interior designer is when a client tells her how much they love their beautiful new interiors.

Known for her sophisticated taste and elegant style, Josie has been attracting clients for more than 25 years. She's seen many trends come and go during that time but says one thing that doesn't change is quality and an attention to detail.

Josie has a degree in interior design from Eastern Michigan University. She started in the field working with Jacobson's department store in Dearborn and, prior to that, at Martin Hiller Interiors in Ann Arbor. At the time, Carl Friewald was the senior designer. Friewald went on to found the well-known Franklin design firm, Perlmutter Friewald.

Kassab worked at Perlmutter Friewald until 1981. Shortly after, she founded her own company, J.S. Kassab Interiors. Since then, she has been working on a wide variety of residential, corporate and institutional projects.

While she employs all design styles, classical elegance is her forte. Widely traveled and multilingual, she loves antiques and often incorporates them into her work. She has attended the Smithsonian Antique Study tour and appreciates the artistic and cultural riches of all civilizations.

As an independent designer, she gets personally involved in all of the firm's projects.

"This has earned me an extremely loyal following. I have done two or three homes for some clients and even their children's homes." She recently helped several clients design their second homes in Florida and enjoys being involved in projects "right from the start." She works well with architects and craftspeople, advising homeowners on every detail, including furniture selections down to the last accessory.

"With each client I strive for an individual and expressive look that reflects the client's personality and their way of life,' she says. "I want to make sure my clients

ABOVE
Welcoming foyer featuring hand painted dome, glazed walls, antique furnishing, and bronze railings.
Photograph by Beth Singer

LEFT
Unique, exquisite and breathtaking two-story family room. Fireplace and chimney are created with hand-glazed tiles, highlighted with Pewabic tile and filled with antique porcelain.
Photograph by Beth Singer

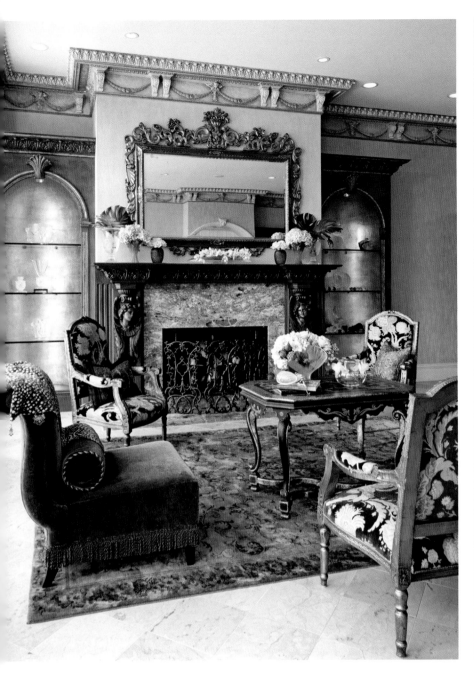

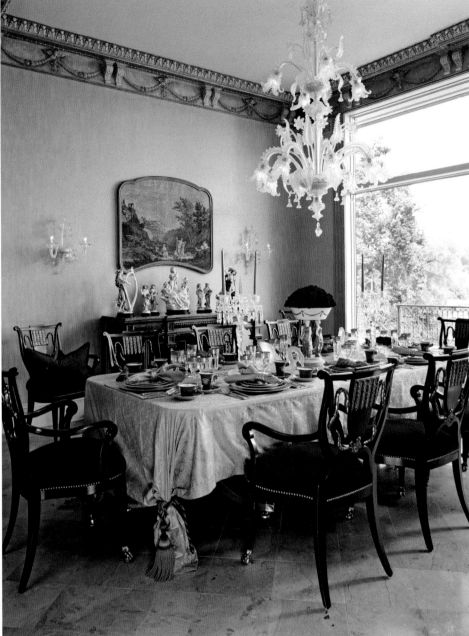

are happy. I keep them happy by putting my heart into my projects and giving each of them 100 percent."

Clients appreciate her creativity and dedication to her work. When she's not working, Josie enjoys spending time with her family. She has raised four children and is currently anticipating the birth of her first grandchild.

"I can't wait," she says.

ABOVE LEFT
Rich gilded niches, an extensive Latique collection, and custom plaster moldings add to the opulence of this room.
Photograph by Beth Singer

ABOVE RIGHT
This festive, royal setting, fit for your most important dinner guest, features a Venetian hand blown chandelier.
Photograph by Beth Singer

FACING PAGE TOP
This relaxed bedroom setting features an antique reproduction headboard and Frette linens.
Photograph by Giovanni Photography

FACING PAGE BOTTOM
Completely renovated seaside retreat creates a casual, comfortable setting featuring a pastel Oriental rug, chenille and leather fabrics, and a stone floor.
Photograph by Giovanni Photography

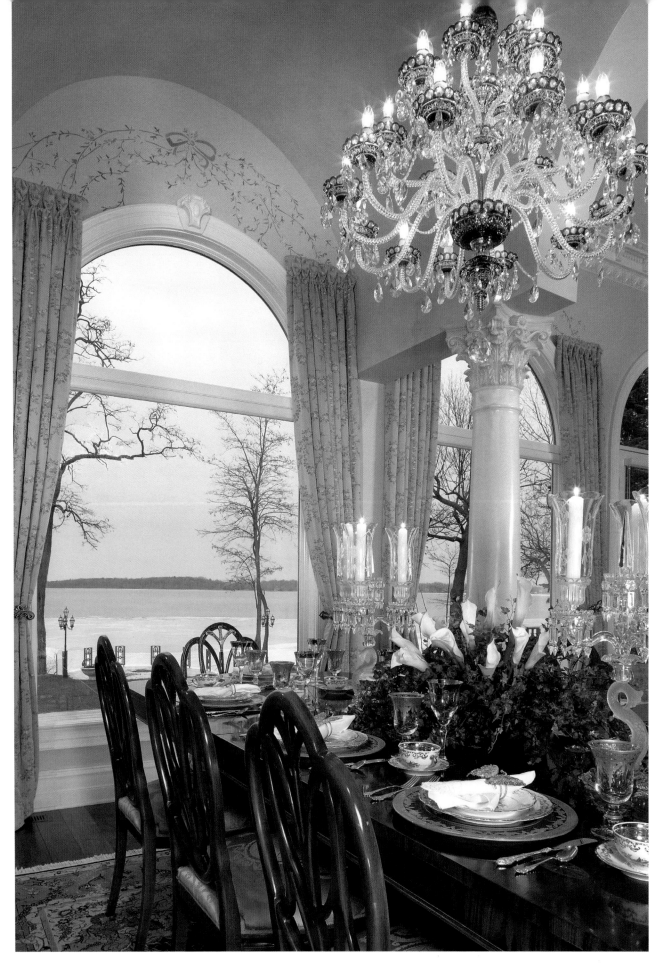

LEFT
This antique European chandelier is the brilliant focal point in a lakeside home's dining room which also features a Persian rug, antique dining table, and barrel ceiling with hand-painted window accents.
Photograph by Beth Singer

FACING PAGE LEFT
Custom vanity complete with gilded fixtures, onyx counter and floor, and fabric upholstered windows.
Photograph by Beth Singer

FACING PAGE RIGHT
Powder room features plaster molding, antique mirror, custom vanity, Oriental Persian rug, and marbleized walls.
Photograph by Beth Singer

MORE ABOUT JOSEPHINE...

WHAT WORDS DESCRIBES YOU BEST?

Quality and elegance.

WHAT BOOK ARE YOU READING?

Who has time for books? But I do read the *New York Times* daily.

WHAT ONE THING WOULD YOU DO TO BRING A DULL HOUSE TO LIFE?

Paintings and rich, quality accessories.

WHAT DO YOU COLLECT?

Antique porcelain and accessories. I also love old paintings.

WHO HAS HAD THE BIGGEST INFLUENCE ON YOUR CAREER?

The late Carl Friewald. His creativity, sense of style and work ethic were incomparable.

J.S. KASSAB INTERIORS
Josephine Sesi Kassab
5156 Crest Knolls Court
Bloomfield Hills, MI 48302
248.851.8696
Fax: 248.851.1702
Cell: 248.891.4949

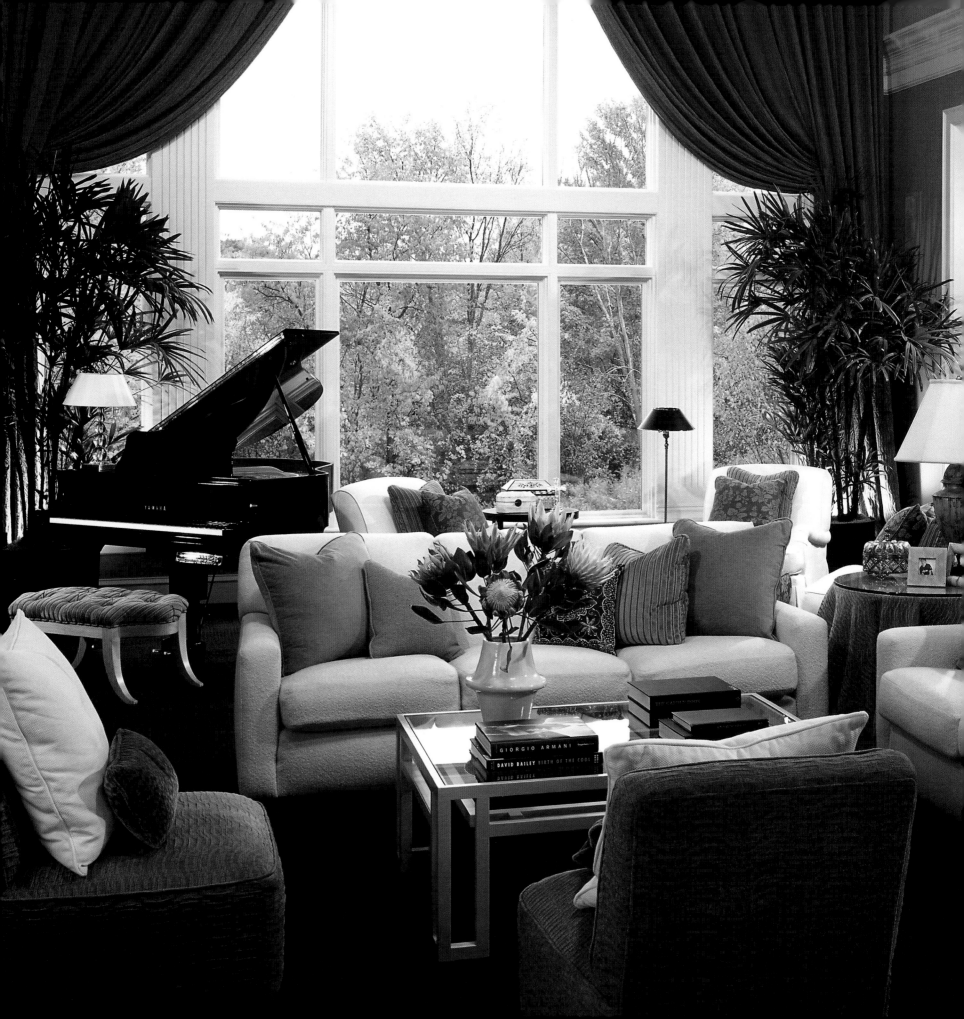

ROCK KAUFFMAN
ROCK HOME STUDIO

Interior designer Rock Kauffman is no stranger to growth. Since designing and renovating his first home 20 years ago, the Grand Rapids-based Kauffman has made a name for himself, along with his design studio and retail spaces, by designing elegant, sophisticated interiors for primary residences and resort homes from Michigan and Florida to California and the Caribbean. Truly an eclectic designer, Kauffman blends trend-forward home furnishings, accessories and color palettes while keeping every interior true to the client's personality and needs.

Along with his team of four associate designers, Kauffman takes on a select and unique group of projects each year, from new construction to room remodels. His vision, confidence and accuracy have won him numerous accolades, including the prestigious *Cosmopolitan Home's* "Home of the Year" award, which he has won twice.

Some of Kauffman's favorite projects are those when there's not even a room to begin designing—just the idea of a room. "I love to start at the beginning with a home, helping clients identify the architect and builder that are just right for their needs and personality," he enthused. He also loves the subsequent stages of a project, when blueprints are created and, he continued, "I see it come to life, which always gives me new insights and ideas."

Kauffman also loves working on kitchens, which he considers the true heart of any home. What inspires him? "Appliances and good quality cabinets in gorgeous finishes." And master bathrooms get special attention, too: "I think, in a master bath, less is more. I like to do things that are clean, simple, elegant and which bring the large size of most new master bathrooms down to a more intimate scale."

LEFT
Rock Home Studio. Classic, clean lines and not overstyling an overscaled room was the end result.
Photograph by Jim Yocum

Clients choose Kauffman for more than just his talent. They love him equally for his genuine, down-to-earth personality and style. "The highest compliment I've received professionally is that my work is completely comfortable," he said. "I'm a blue jeans and t-shirt kind of guy."

For most clients, there's an "a-ha!" moment (also affectionately known as "In Rock We Trust") where a client really opens up to the designer's vision. "Sometimes it's in a first meeting, sometimes it's when I present my ideas, but there's always an essential emotional connection between my clients and me," confided Kauffman.

Like all creative artists, Kauffman is constantly pursuing new inspirations, challenges and personal growth. His newest venture, a retail and design studio concept, is scheduled to open in early summer. With it, he will continue to bring his trademark sophistication to West Michigan and beyond.

He sees this new space as an evolution of his own thinking and aesthetic. "This year, I see myself going more organic, more green in my thinking and pure in my style," explained Kauffman. "The style has evolved to be less urban, more sophisticated, comfortable but cool at the same time. People don't just 'do' a single style anymore. Instead, interiors are varied and engaging, reflective of the owner's personal interests."

"My clients hold distinctive accessories and furnishings in high regard," he continued. "This store is an homage to them and a reflection of my desire to help them find beautiful pieces right in their own backyard."

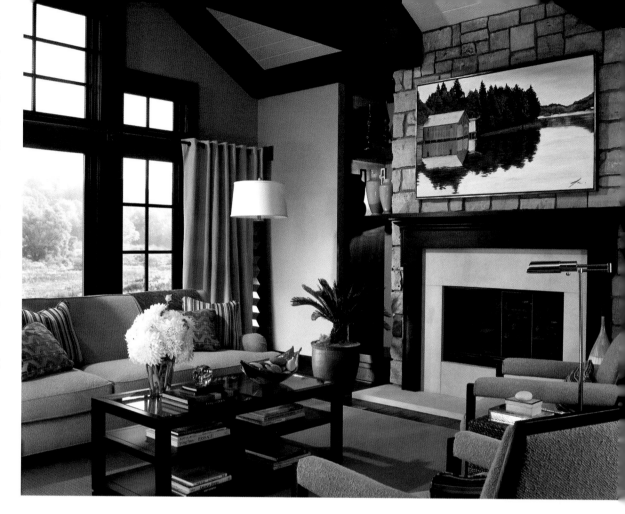

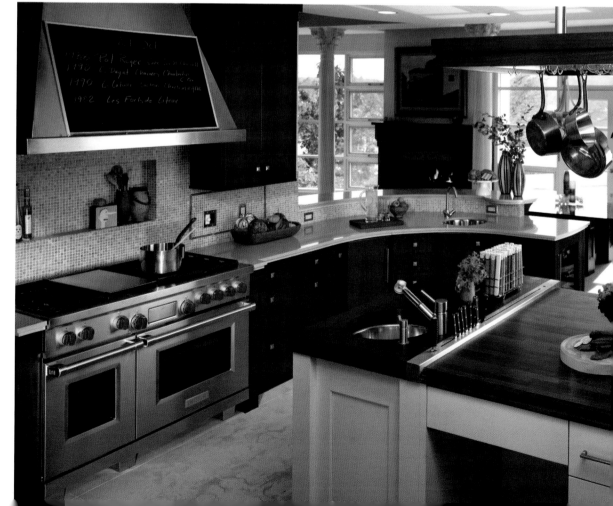

TOP RIGHT
Rock Home Studio. Gilda's Club Showcase Home. Artwork by Jamie Miller.
Photograph by Jim Yocum

BOTTOM RIGHT
Rock Home Studio. Sub-Zero Wolf Contest.
Photograph by David Ellison

FACING PAGE
Rock Home Studio. Dining room from *Cosmopolitan Home Magazine's* "Home of the Year 2005."
Photograph by Jim Yocum

MORE ABOUT
ROCK...

WHAT PERSONAL INDULGENCE DO YOU
SPEND THE MOST MONEY ON?

Travel.

NAME ONE THING MOST PEOPLE DON'T
KNOW ABOUT YOU.

Collaborating with like-minded people fuels my
creative fires.

WHAT COLOR BEST DESCRIBES YOU?

Charcoal.

IF YOU COULD ELIMINATE ONE DESIGN
ARCHITECTURAL/BUILDING TECHNIQUE OR
STYLE FROM THE WORLD, WHAT WOULD
IT BE?

Vinyl siding.

ROCK HOME STUDIO
Rock Kauffman
6744 Cascade Road SE
Grand Rapids, MI 49546
616.774.9200
www.rockhomestudio.com

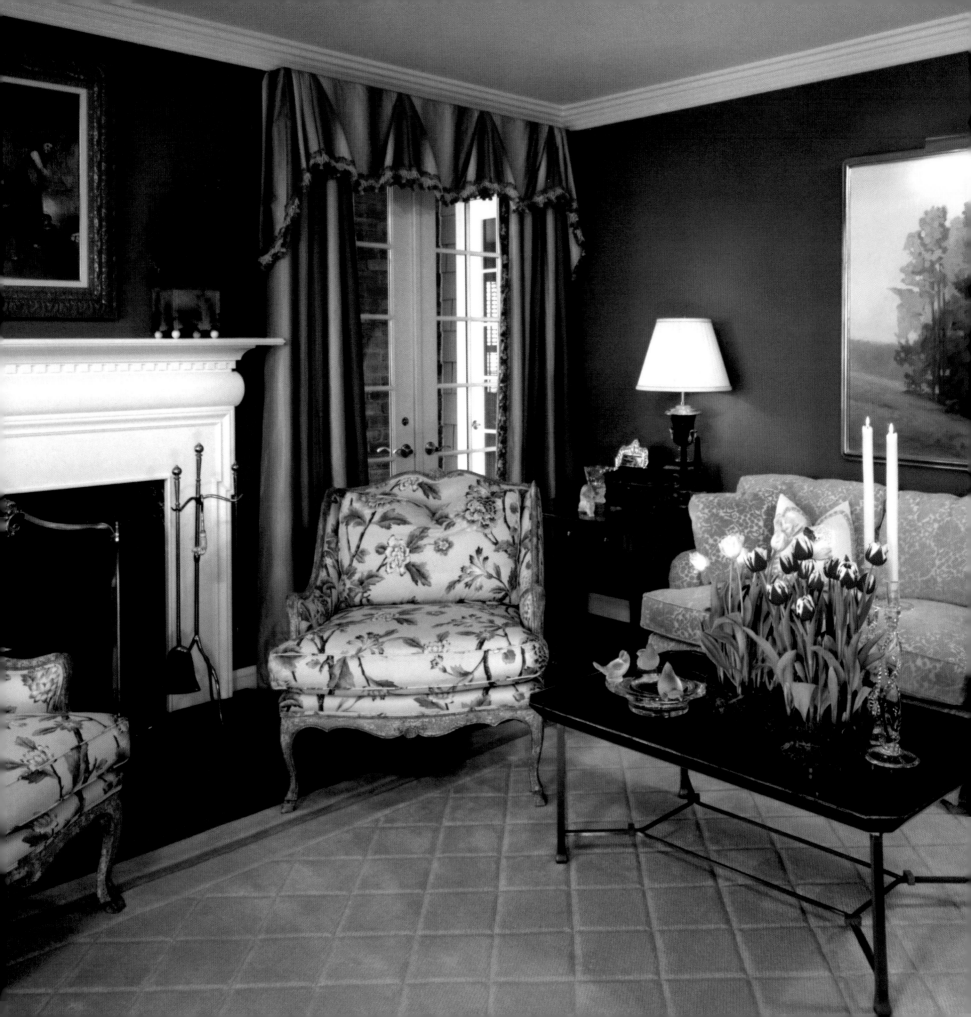

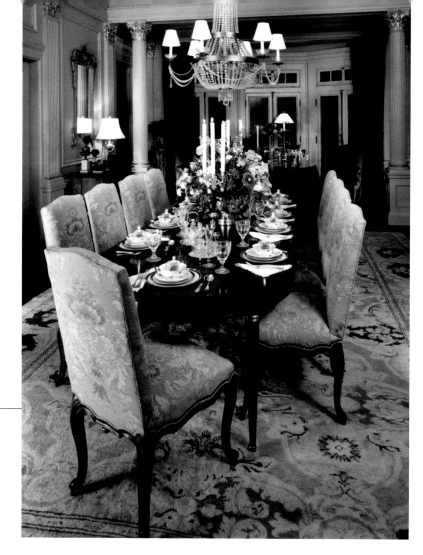

DJ KENNEDY
KENNEDY & COMPANY

While he grew up in Bloomfield Hills and studied interior design at Kendall School of Design in Grand Rapids, D.J. Kennedy's ever-growing client list reads like a "Who's Who" of notable Grosse Pointe families. Since founding Kennedy & Company in 1979, he has designed homes from Florida to Northern Michigan as well as many in between. He has even designed the interiors of a few yachts and the 1920's mansion of one of Detroit's recent mayors, Dennis Archer.

Whether he's decorating a yacht or a classic estate, Kennedy describes his design philosophy as "upbeat traditional." He's moved beyond the clubby Ralph-Lauren-inspired style for which he was once known and has embraced a cleaner, fresher sensibility built on antiques and classic style. He calls it "tradition with a twist."

"I never compromise on good lines, good bones or good quality," he says. "Color trends change, style trends change, but good quality and timeless designs never date themselves."

An avid boater, Kennedy finds life on the water both relaxing and inspiring and, when not working, enjoys spending time on his 56-foot Hatteras Motor Yacht. "My boat is our floating cottage," he claims.

A devoted antiquer, he also enjoys collecting china, porcelain, tortoiseshell boxes and more. Antiques and personal collections, he says, go a long way toward making a house a home.

"I love a good mix of English and French, along with antiques and some surprises in the art work. I also like soft contemporary pieces that are framed traditionally." DJ says using a designer can open doors and, in the end, save clients money and costly mistakes.

ABOVE
Dining room in a Lakefront Designer Showhouse, anchored by an antique European rug from Stark Carpet, and beautiful architectural elements.

LEFT
Formal living room in a Grosse Pointe residence blends an eclectic mix of French and English antiques, with contemporary and antique art which helps to create an inviting atmosphere.

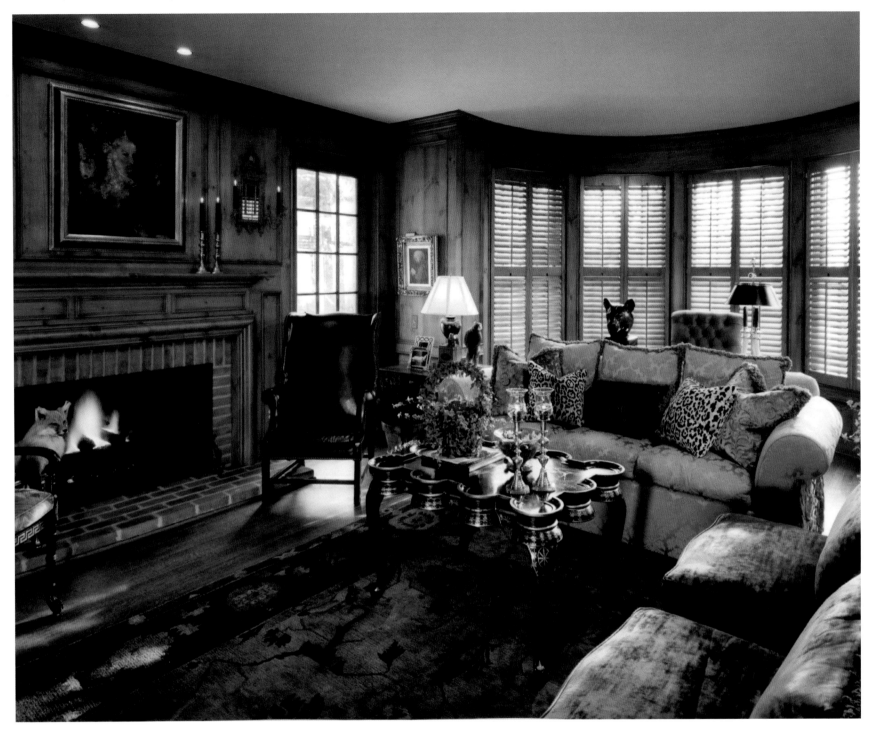

"A good designer has many resources, ideas and advice that a homeowner doesn't have access to and can't get off the street," he says. "In the end, the money saved from avoidable mistakes will far offset the price of using a qualified professional."

While he believes a designer's input is invaluable, he never tries to dictate a particular style to his clients.

He says, "In the end, no room is complete without the personality of the homeowner."

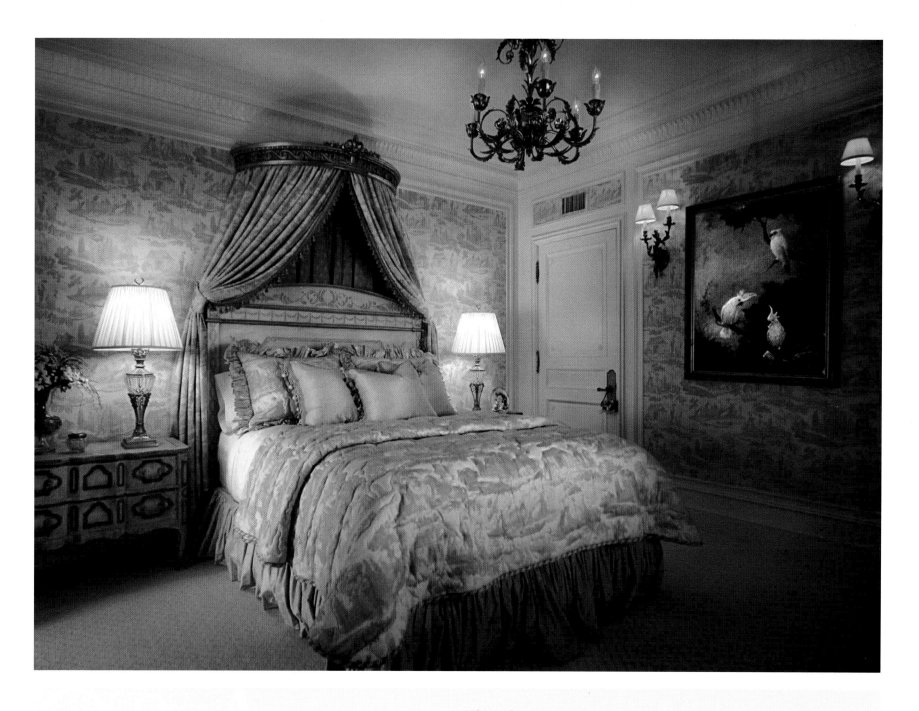

MORE ABOUT DJ...

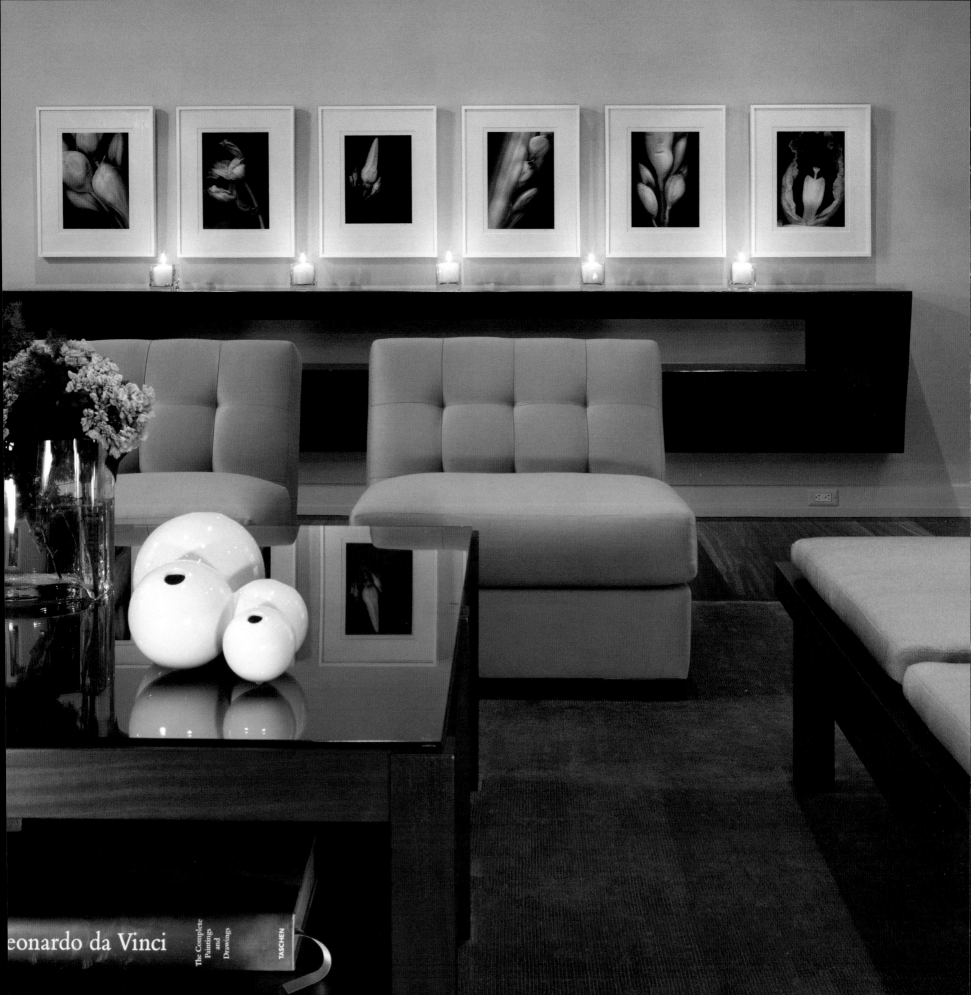

eonardo da Vinci The Complete Paintings and Drawings TASCHEN

JEFFREY KING

JEFFREY KING INTERIORS

A sense of purity. Serenity of space. Calm color and clean design. Whether it's traditional, eclectic or contemporary, this is the philosophy of Jeffrey King Interiors.

The 15-year-old interior design firm, made up of King and associate Amy Weinstein, has designed the homes of many of metro Detroit's movers and shakers. Whatever the profession or income, however, the rules of good design remain the same, says King.

"Good design means editing out life's clutter," he says. "It's about thinking things through. Knowing where someone reads or puts their keys. When everything is in its place, a home feels harmonious. That's our goal." Weinstein says the pair is currently inspired by classical forms and colors commonly found in nature.

"Our vision is expressed through texture, pattern and color, with a strong emphasis on proportion. Our goal is the successful marriage of all of these elements." When all is said and done, says King, home should be the place where you can nourish your soul. It's a haven where you should be able to unwind before launching the next day. He says, "Great design should inspire and support a beautiful life."

ABOVE
Jeffrey King and Amy Weinstein blend their design wisdom and remain committed to their unique collaborative partnership.
Photograph by David Frechette

LEFT
A supremely sophisticated living room with pure geometric furnishings, muted watery tones, and an array of textures, this space reflects great classic design.
Photograph by Beth Singer

BELOW
The character of this room belongs to the wall with the fireplace. It is simple, yet bold, and it invites us into this peaceful environment.
Photograph by Beth Singer

JEFFREY KING INTERIORS
Jeffrey King
Amy Weinstein
166 West Maple #200
Birmingham, MI 48009
248.646.3353
Fax: 248.646.3828

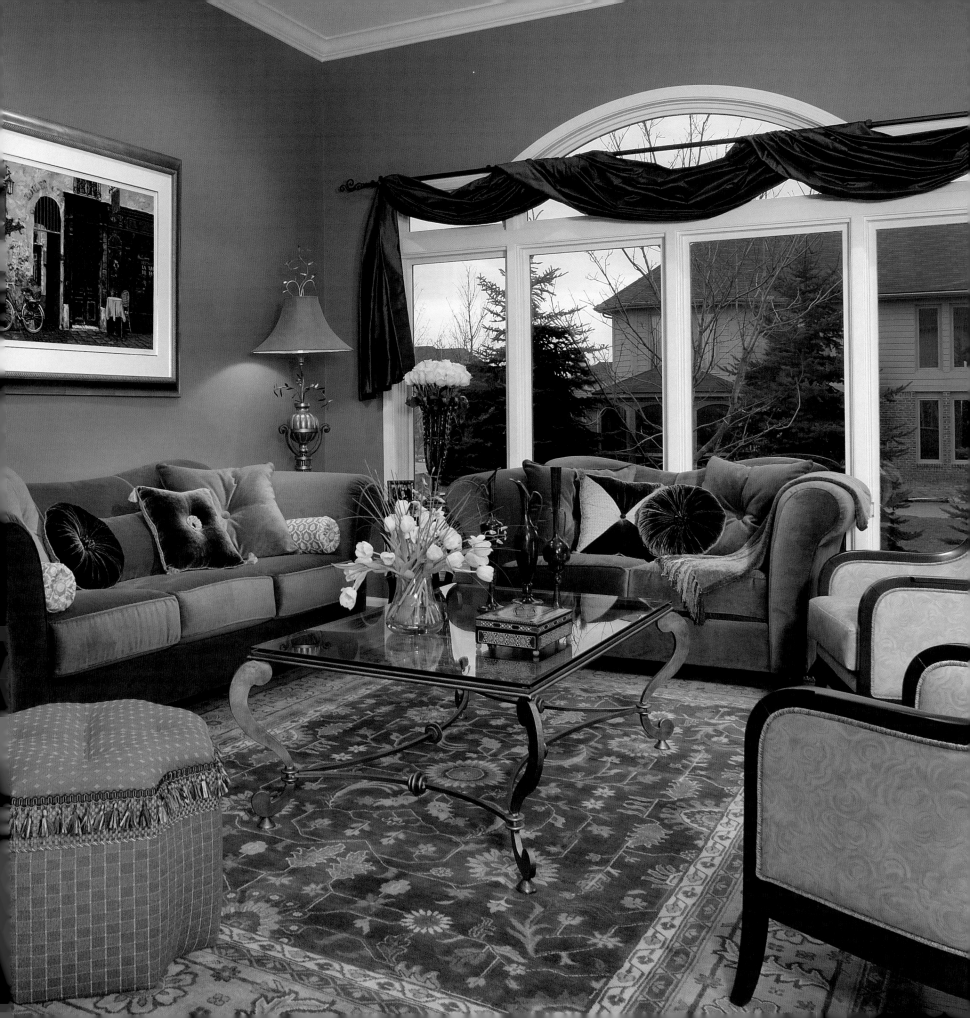

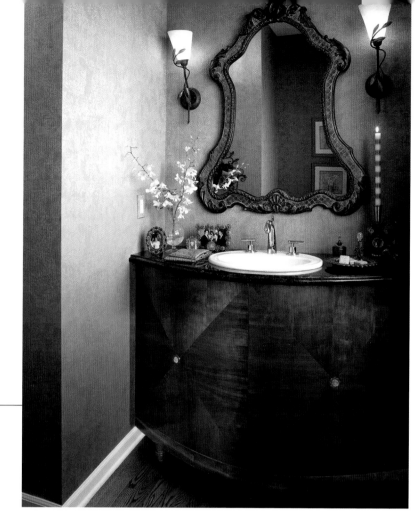

BARBI KRASS
COLORWORKS STUDIO

"I love having the ability to transform a space, making it and my client's life more beautiful," says Barbi Krass of the best part of being an interior designer. Krass, of Colorworks Studio, was recently featured on HGTV's "Designer's Challenge." In the show, she helped transform a former 1920's warehouse in Detroit into contemporary living space for a 30-something bachelor. The flexible floor plan with its multiple living spaces takes full advantage of the city's views and ultimately earned the client's approval.

"The loft project had my entire team thinking out of the box," says Barbi. "We really had to be innovative and competitive."

Ironically, she hung up on the producer when the call from the network first came. Unknown to her, her 30-year-old daughter had sent in Krass's portfolio without her knowing. "I thought it was a joke and hung up," she says. "Luckily they called back."

While born on the East Coast and schooled in Boston, Krass has spent 35 years in Michigan and has operated Colorworks since 1978. She prides herself on being able to provide a complete range of design services in-house, from large-scale construction, space planning, furnishings, custom fabrication, kitchen and bath design to smaller projects involving windows, artwork and accessories. "I love working in every style. It keeps us all stretching, learning new skills and finding new resources," she says. "Overall, I like a clean space that's not too fussy, with a design continuity from room to room."

She believes that each project should reflect the personal style of its owner. Beyond that, she strives to inject a project with a sense of enjoyment. "In the end, the most satisfying comment for me is having a client say the project was fun," she says.

ABOVE
Powder room's small space called for a custom vanity in figured anigre wood with a mitered door design, granite top and jeweled custom hardware. Walls are covered in silk damask in a neutral khaki tone.
Photograph by Beth Singer

LEFT
Living room in deep bronze, mahogany, and cornsilk fabrics with wood and metal accents.
Photograph by Beth Singer

Photograph by Heather Saunders

COLORWORKS STUDIO
Barbi Krass Allied Member, ASID
7001 Orchard Lake Road
West Bloomfield, MI 48322
248.851.7540
www.colorworksstudio.com

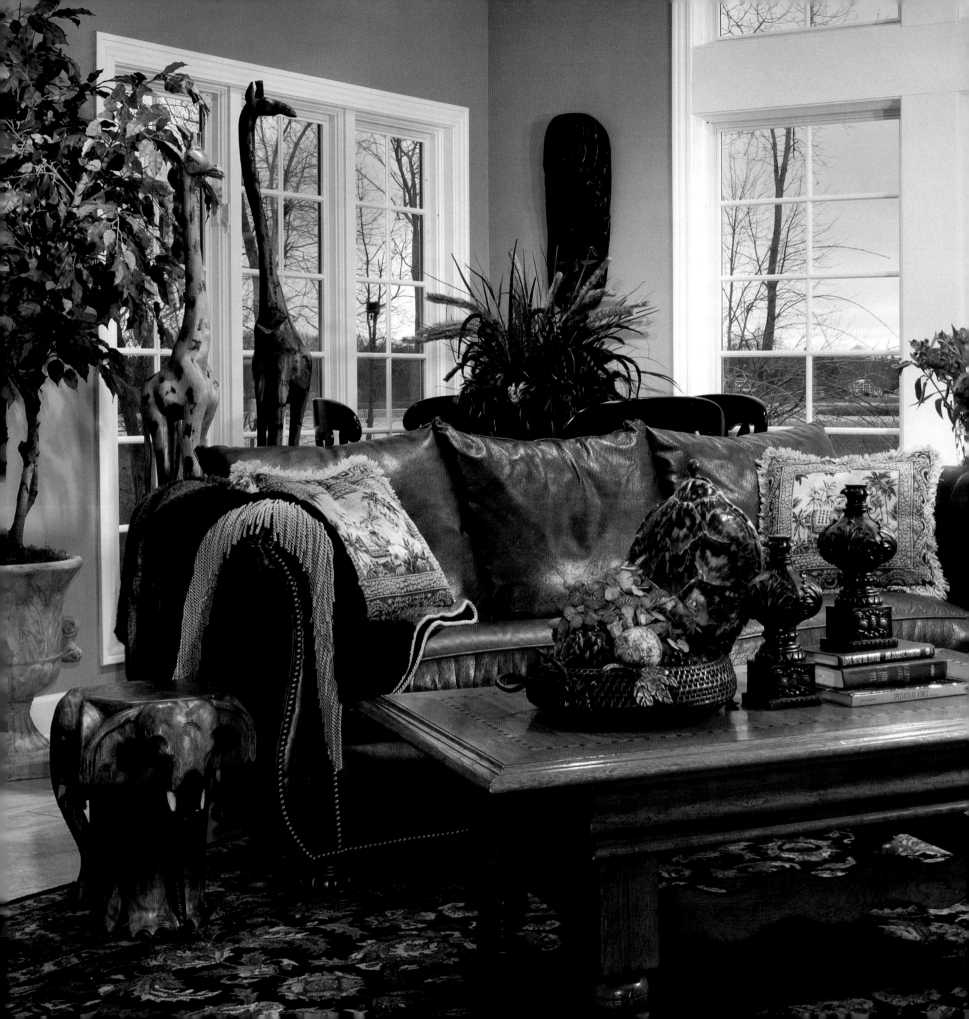

TERRI KUNKEL
TK DESIGNS

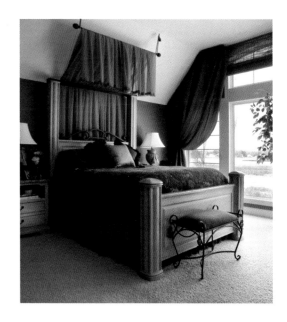

As a little girl growing up in southwestern Michigan, Terri Kunkel often played princess. But she never dreamed TK Designs, her interior design firm, would be assisting the Japanese royal family.

After studying design at Western Michigan University and spending years as an interior designer at Grand Rapids' elite Klingmans, one of Kunkel's loyal clients recommended her to the Prince and Princess of Japan. Now the master bedroom suite in the Royal Palace showcases the TK Design touch with John Widdicomb furniture adorned in traditional red and gold silks. Already having made her mark with residential designs along Lake Michigan's waterfront, including palatial estates, glamorous yachts, Chicago

ABOVE
It's a romantic trip through this master bedroom suite overlooking the waters of an inlet from Lake Michigan. Above the bed's headboard, Terri ingeniously designed a canopy suspended from the ceiling to create a cozy retreat. A monochromatic palette was used to ensure a soothing atmosphere.
Photograph by Beth Singer

LEFT
There is no better way to view one of Michigan's fabulous waterways than from this spacious window-walled living room. Terri creates a simply luxurious environment by integrating her treasures from travels in South Africa and abroad. The Hancock & Moore nail studded leather sofa along with wool rug add harmony and serenity to the setting. For an eclectic mix, a John Widdicomb hand-carved spider-back chair with gold gild and animal print fabric is added. Travertine marble tiles blend for a natural yet elegant look.
Photograph by Beth Singer

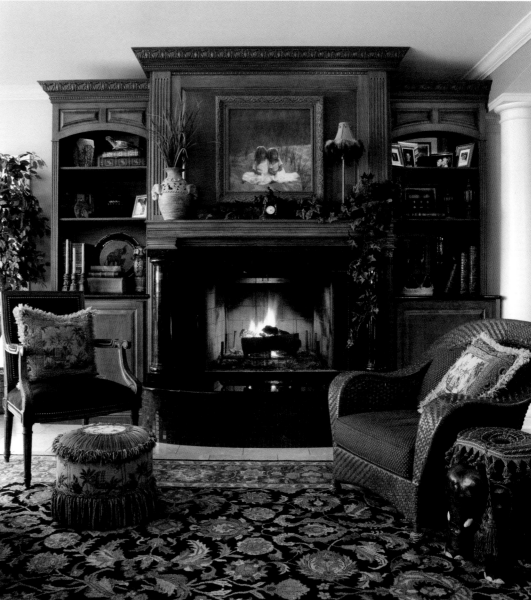

high-rises and standout commercial creations, Kunkel has now added a suite at the royal palace in Tokyo to her portfolio.

Having navigated the turmoil of the distinctly individual personalities of her own twin girls and a boy, Kunkel has perfected the art of reading the tastes of her clients. Although she personally loves the traditional Old World style, she delights in reflecting a client's vision in her designs.

African, modern, traditional, British West Indies or rustic, such as the Kunkel-styled home featured in *Log Home Living* magazine, Kunkel's designs are always original, creative and artistic but often daring, innovative and totally unexpected as well.

ABOVE LEFT
This elegant niche sets the mood for a comfortable evening of reading. Terri uses candles and rich wood tones from the "Gostelowe" chest and the John Widdicomb revolving bookcase to make this sitting area especially enchanting. The chest is by Kindel Furniture and is a reproduction of an original from the National Trust for Historic Preservation collection. The unusual lamp adds an exotic touch and completes the setting.
Photograph by Beth Singer

ABOVE RIGHT
The impressive fireplace with stately solid granite pillars which Terri had specially crafted and imported from Brazil, along with made-to-order intricately cut tiles on the base of the hearth, create the focal point for this custom designed dramatic wall of wood. Feathers and fringe soften the space to make an inviting conversation area.
Photograph by Beth Singer

FACING PAGE LEFT
This luxurious living room was transformed to feature a layered mix of textured and patterned fabrics covering custom down filled upholstery creating an alluring corner for one to be enveloped. Terri painstakingly selected the tiles and then designed the custom built cocktail table shipped in from Texas.
Photograph by Beth Singer

FACING PAGE RIGHT
A new addition to this waterfront home showcases the master suite with suspended hand-hewn beams creating dramatic arches that frame the view to the lake. The hand-painted antiqued walls make the perfect backdrop for the custom silk draperies. Down-filled chairs bring elegance and sophistication to the environment. The addition was long in coming since the client refused to continue the construction without Terri while she was on bed rest with the pregnancy of her twins!
Photograph by Beth Singer

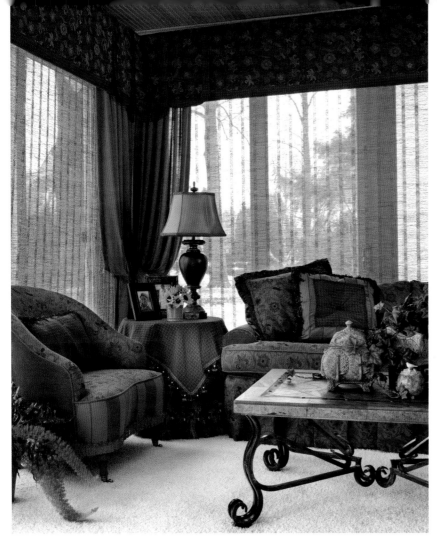

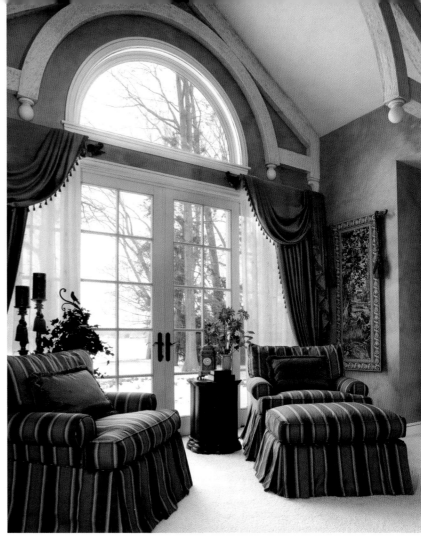

MORE ABOUT TERRI...

DESCRIBE YOUR STYLE OR DESIGN PREFERENCES:

I like to break the mold and throw in something unexpected.

WHAT COLOR BEST DESCRIBES YOU AND WHY?

Periwinkle. A little exotic and daring, a bit out of the ordinary, beautiful but unusual.

YOU WOULDN'T KNOW IT, BUT MY FRIENDS WOULD TELL YOU
I AM...

A Dave Mathews Band groupie.

WHAT EXCITES YOU MOST ABOUT BEING PART OF
SPECTACULAR HOMES?

Being recognized with all of the other fabulous designers in Michgian. The only thing
that could be better is if Dave Matthews was sitting in one of my photos!

WHAT PERSONAL INDULGENCE DO YOU SPEND THE MOST
MONEY ON?

Jewelry. I'm a jewel-a-holic!

WHAT'S THE BEST PART OF BEING AN INTERIOR DESIGNER?

Becoming good friends with my clients. And I like having the vision to see a whole
project come together knowing it will be fabulous. You have to be confident to spend
other people's money!

WHAT'S THE MOST UNUSUAL TECHNIQUE YOU'VE USED IN ONE OF
YOUR PROJECTS?

An antique painting process for a client. It took about a year to complete. I felt
like Michelangelo!

TK DESIGNS
Terri Kunkel ASID, NCIDQ
6579 Heron Bay Drive
Saugatuck, MI 48453
616.836.4204
tkdesigns1@verizon.net

Francine Laenen
FRANCINE LAENEN INTERIORS

Francine Laenen's father was a builder and an architect and designed and built the 1950's Frank Lloyd Wright-style contemporary home where she grew up. As a child, she would often visit job sites with her father. She attributes her love of design today, in part, to her artistic family.

"I think I inherited my dad's creativity," she says. "Our house growing up had black walls and white carpet. Many of my friends who lived in more traditional homes thought it was the coolest house ever."

Growing up in a creative environment paid off. After studying design at Wayne State, Laenen took a break to raise her two children before getting back into the business at age 30. After working for a variety of metro Detroit design firms, she started Francine Laenen Interiors in 1983. While she credits her father with her love of design, more than 20 years later, she's better known for a classic look and for her intricately detailed, European-inspired interiors.

ABOVE
Stairway features Stanton wool carpeting and Carlisle wall covering.
Photograph by Beth Singer

LEFT
Living room features a Platt cocktail table while the B. Berger drapery fabric creates an inviting space.
Photograph by Beth Singer

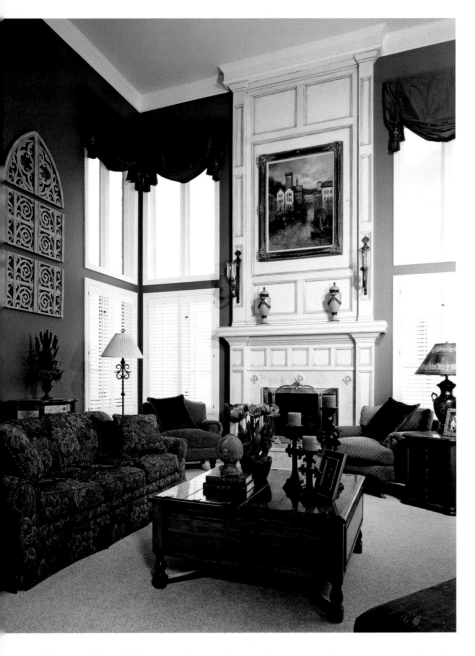

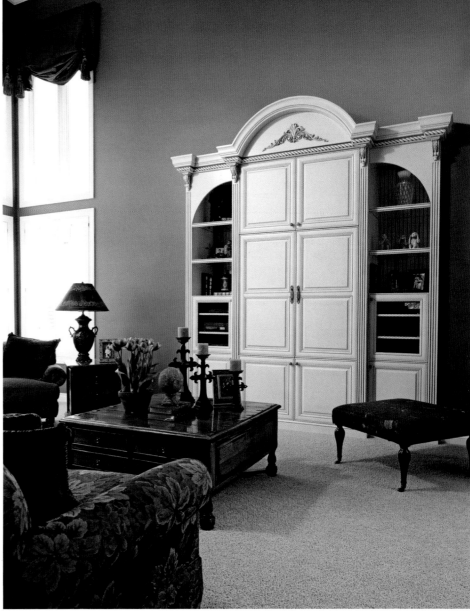

It's a look found in her own house, she says. "I can appreciate contemporary interiors, but I personally feel most comfortable in European-style homes with an Old World feel. I love French and Italian interiors and all of the wonderful details you find in them."

Detail, in fact, is one of the things for which Laenen is best known. "I love it all, from trim to pillows to drapes," she says.

The one-woman design firm takes up to 10 clients at a time and says the best part of being in business for herself is that it allows her to have her hand in every decision and monitor a job closely so that everything goes smoothly. She doesn't mind a challenge, however. One of her most recent challenging projects included a large new home that was well built yet had little architectural detail. Through a skillful use of color and the addition of detail, Laenen took the house from bland to beautiful. She even won an

award for the project's skillful use of color and accessories from a local design magazine. Classic or contemporary, Laenen believes in using color as a tool. "I'm not a beige person. I truly believe color has the ability to transform a room."

ABOVE LEFT
Family room with a cocktail table by Lorts, sofa by Modern Classic, custom-made fireplace with hand glazing and tumbled marble.
Photograph by Beth Singer

ABOVE RIGHT
Family room with recessed custom-made cabinetry.
Photograph by Beth Singer

FACING PAGE
Dining room features a beautiful Persian rug, custom-made drapes using Duralee fabrics, Carlisle wall covering, and chairs in bay window by JDM.
Photograph by Beth Singer

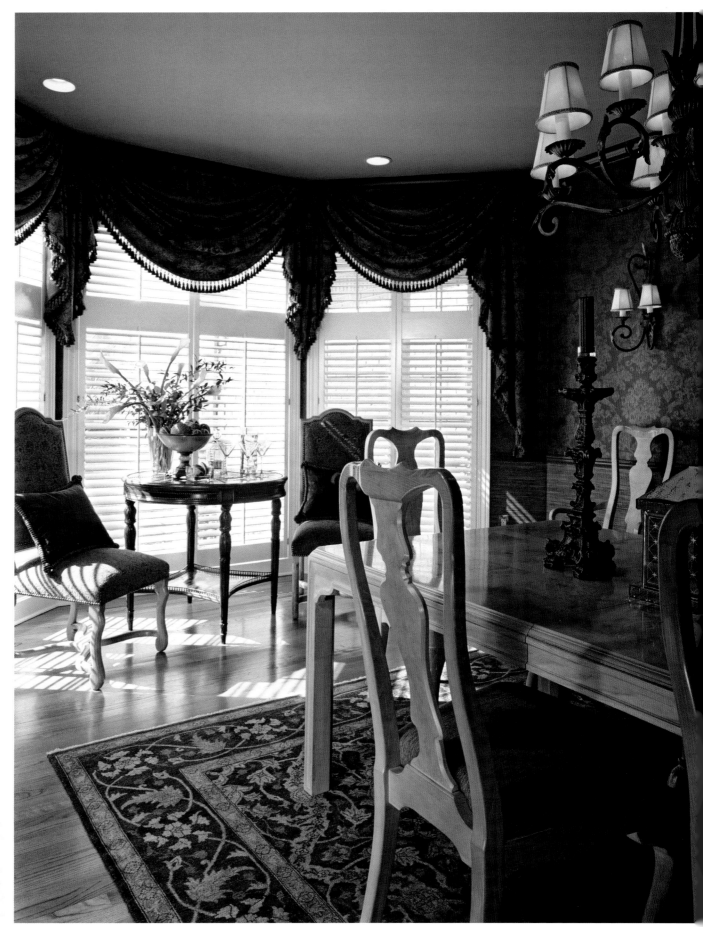

FRANCINE LAENEN INTERIORS
Francine Laenen
5648 Clearview Drive
Troy, MI 48098
248.709.9300
Fax: 248.952.5369

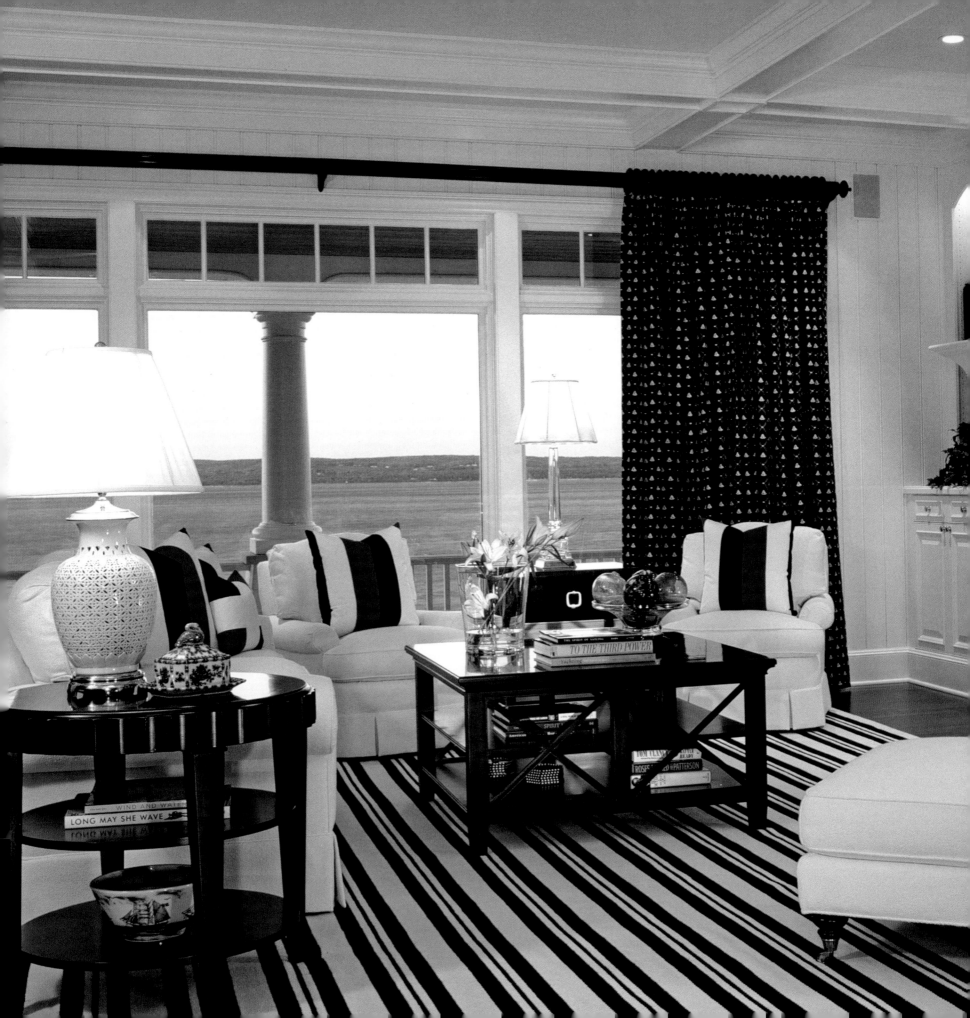

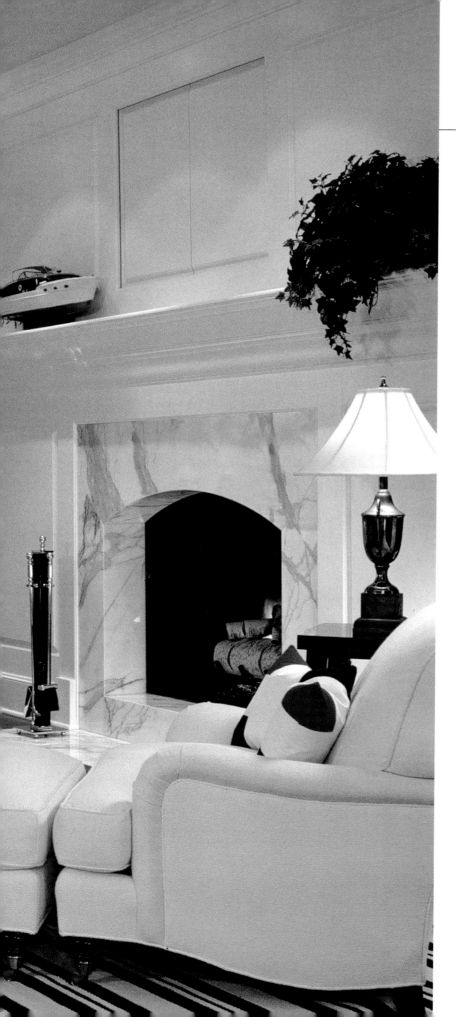

LINDA MASON
MASON INTERIORS

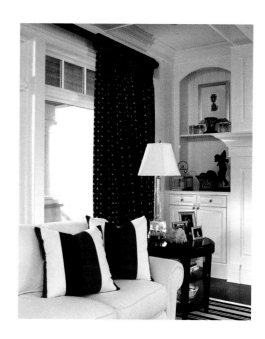

C lassic, contemporary or cottage—Linda Chaffee Mason is known for listening to her clients and interpreting their ideas into spaces they love.

"It's important when designing a home to reflect the client's needs, desires and tastes while staying within the perimeters of scale, appropriateness for the environment and consideration of how the home will be used," she says.

Mason's background includes several years of teaching at the elementary and high school level as well as more than 30 years in design. She moved to northern Michigan after years of summering there as a child. The area's sandy beaches and fresh waters now serve as the backdrop to her interior design studio and home accessories store.

"At one point, I had three stores in a three-block area, one focusing on kitchen, the second on bed and bath and the third on interior design," she remembers. "It became clear that my love for interiors encompassed all three, so I consolidated into my current space."

ABOVE & LEFT
Timeless and inviting, this navy and white themed living room complements the spectacular lake view!
Photograph by Beth Singer

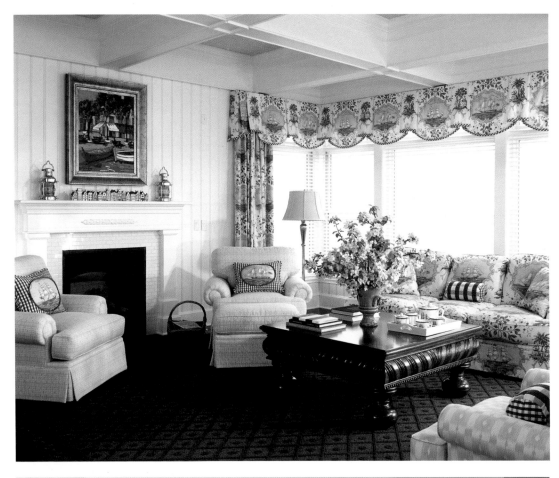

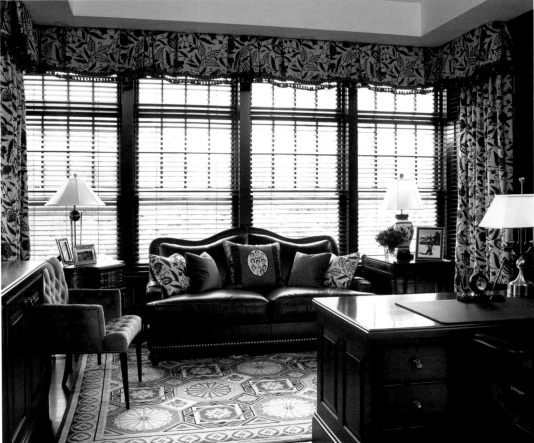

Whether new construction or a remodel, Linda's experience and trained eye have won the respect of architects, builders and clients. Projects have included homes in Canada, Switzerland, Florida and even a few yachts. Her favorite projects include working on the many historical cottages built in the 1800s in Northern Michigan as summer homes for affluent families from Chicago, Cincinnati and St. Louis looking to escape the heat of the city.

"There is so much charm in this area," she says of Northern Michigan. "I love the feeling of stepping back in time and experiencing the history and stories of the people who summered here."

Linda's own home has been featured in several magazines and on HGTV's "Best in American Design."

During her time as a designer, she has developed life-long relationships with her clients. "Most projects take many months to several years to complete and fine tune," she says. "While we all want our projects to be works of art, first and foremost they must be homes that function and provide for the needs of the family."

Linda conveys, "If I have done my job successfully, it will be reflected in the smiles on clients' faces and in their joy of living in the spaces we've created."

TOP LEFT
As clipper ships set sail across the softly scalloped valance, Linda's clients gather in this active family room to plan their day or simply enjoy the view.
Photograph by Jim Yochum

BOTTOM LEFT
Crewel drapery embellished with dramatic fringe and rich leather upholstery add warmth to this richly mahogany paneled home office.
Photograph by Jim Yochum

FACING PAGE
The graceful curves of this room are repeated on the headboard, chaise, and tufted chair and ottoman. The soft blue hues, with a touch of apricot, make this luxurious master suite a perfect retreat.
Photograph by Beth Singer

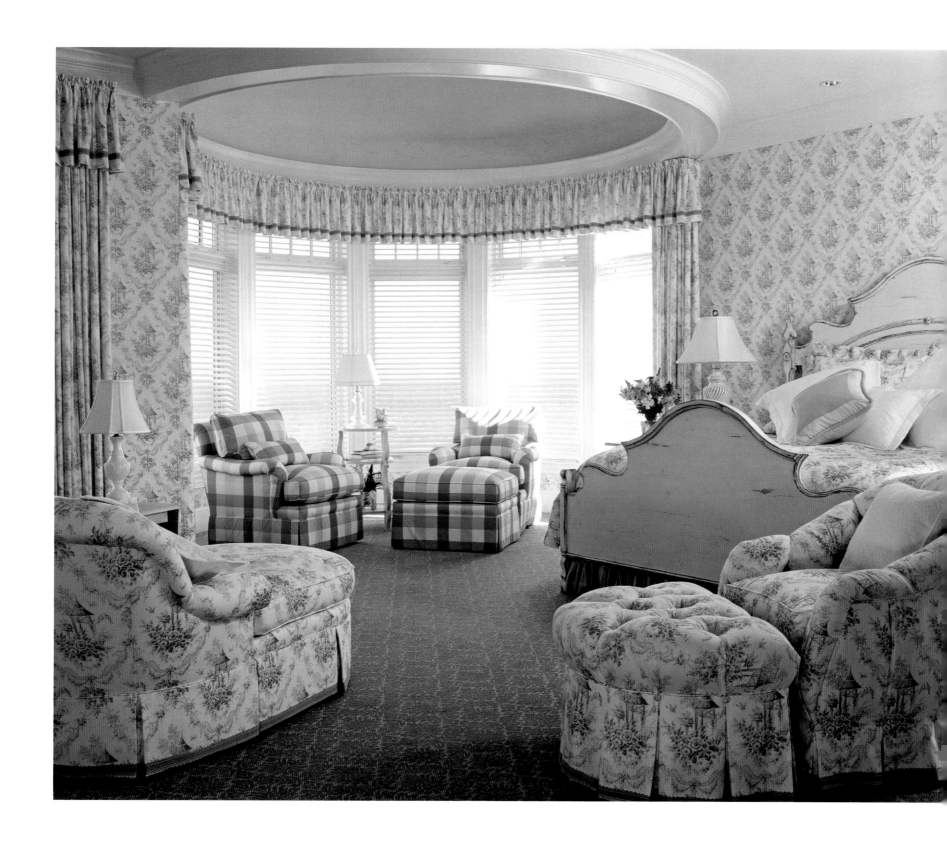

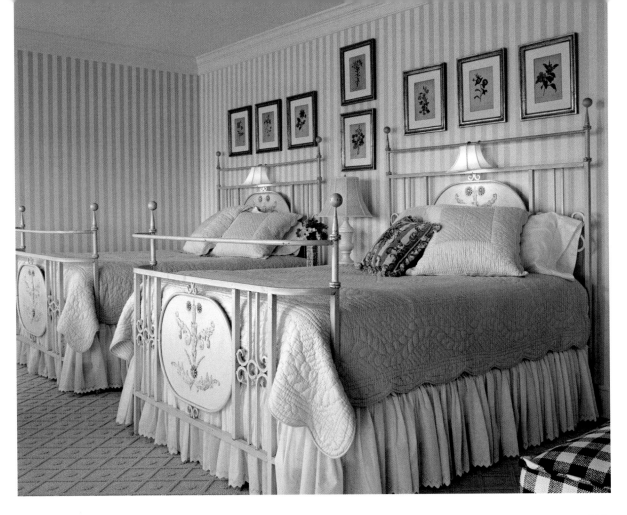

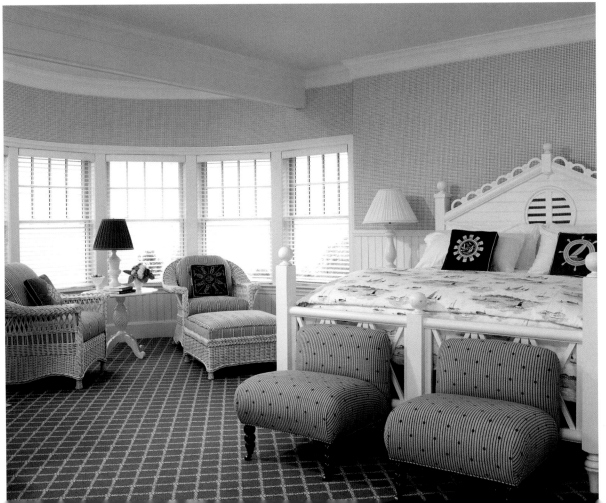

TOP LEFT
The charming framed botanicals add the finishing touch to this wonderful and sunny room.
Photograph by Beth Singer

BOTTOM LEFT
Vintage boat cushions provide whimsy in this nautical-themed room with a dramatic view of Lake Michigan.
Photograph by Jim Yochum

FACING PAGE LEFT
White beadboard paneling and a unique porthole door welcome visitors to this lake house retreat.
Photograph by Beth Singer

FACING PAGE RIGHT
Wicker lounge chairs and an upholstered ottoman provide a cozy conversation area on this turreted enclosed porch.
Photograph by Beth Singer

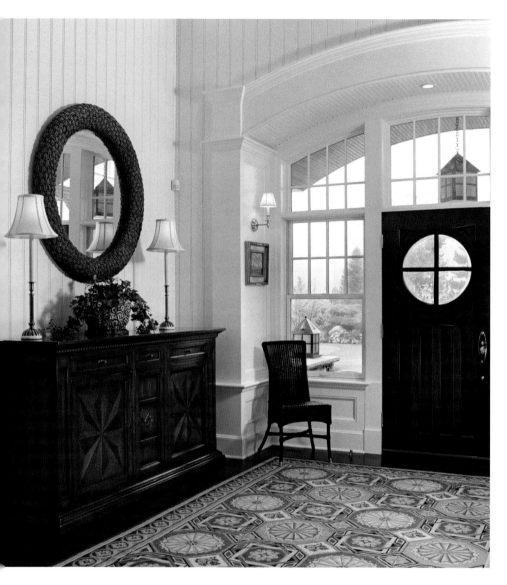

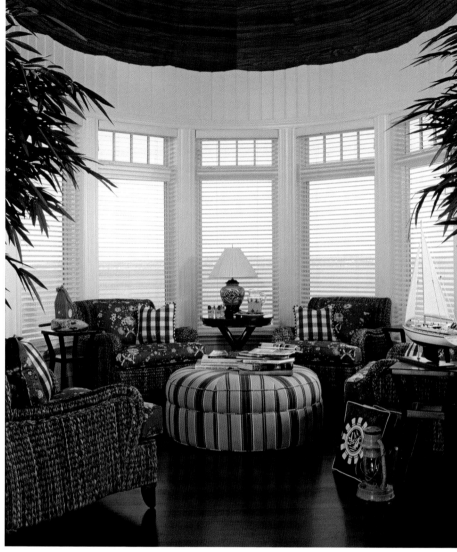

MORE ABOUT LINDA...

WHAT PERSONAL INDULGENCE DO YOU SPEND THE MOST
MONEY ON?

Clothes. I love the classic style and exquisite fabrics of Ralph Lauren and Armani.

WHAT ONE ELEMENT OF STYLE OR PHILOSOPHY HAVE YOU STUCK
WITH FOR YEARS THAT STILL WORKS FOR YOU TODAY?

Always provide good lighting and comfortable furniture.

WHAT IS THE SINGLE THING YOU WOULD DO TO BRING A DULL
HOUSE TO LIFE?

Paint it a great color!

WHAT COLOR BEST DESCRIBES YOU AND WHY?

Navy Blue. I love it throughout the year. It's classic, rich and timeless, as I hope my
work is.

WHAT BOOK ARE YOU READING RIGHT NOW?

False Impressions by Jeffrey Archer.

WHAT SEPARATES YOU FROM YOUR COMPETITION?

A great sense of color, space and proportion... and patience!

MASON INTERIORS
Linda Mason, Allied Member ASID
102 Michigan Avenue
Charlivoix, MI 49720
231.547.9953
Fax: 231.547.1134
www.masoninteriors.com

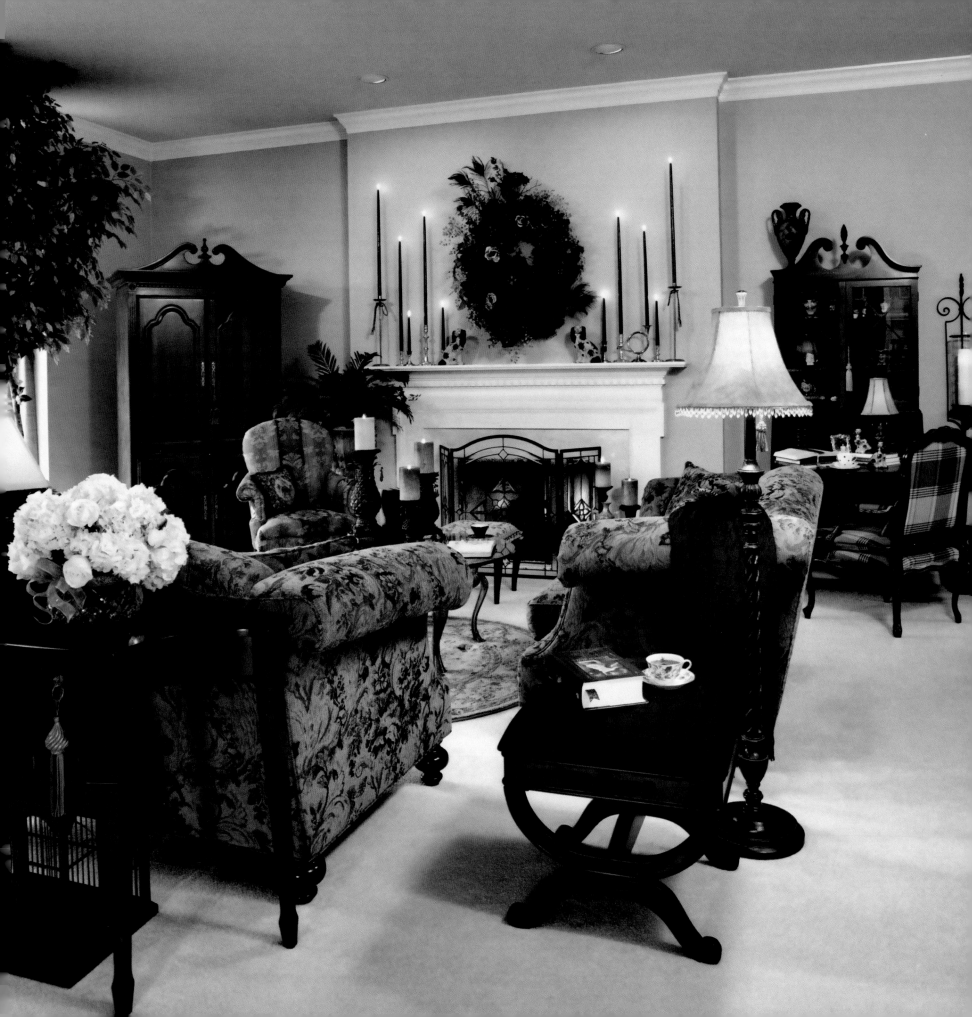

ANNE MUSSON

AM DESIGNS, LLC

A nne Musson of Plymouth began her interior design career 16 years ago as a professional Christmas decorator. Her focus quickly expanded into a full-service interior design business now known as AM Designs. With a business degree to complement a degree in merchandising management, Anne's diverse resume includes banking, franchise financing, retail buying, visual display and teaching as an adjunct professor. Anne is also a product designer for an import company, which helps her maintain a finger on the pulse of the home décor industry. "It is very exciting to see products you helped design go to market," she says.

Anne credits the late interior designer Sister Parish as the biggest influence on her career. "She started out small, mostly for fun and to make a few extra dollars and grew into one of the world's most renowned designers." Like Parish, Anne prefers "comfortably elegant" interiors. Her personal preference is traditional, with a mix of unusual pieces. "Each room needs a little of the unexpected." Anne considers herself a versatile designer with the ability to accommodate whatever style her client is looking for. "Seeing my clients excited about their new rooms is the best part of the job," says Anne. "When they're excited, I'm excited. For me, excitement is confirmation of a job well done."

ABOVE
An antique sideboard in the foyer proudly displays a pair of Staffordshire dogs Anne purchased in London.
Photograph by Jeff Garland

LEFT
Anne's cozy living room features 12' ceilings, antique family heirlooms, an award-winning wreath she designed and an unseen baby grand piano.
Photograph by Jeff Garland

AM DESIGNS, LLC
Anne Musson
8900 Quail Circle
Plymouth, MI 48170
734.455.1255
Fax: 734.455.1255

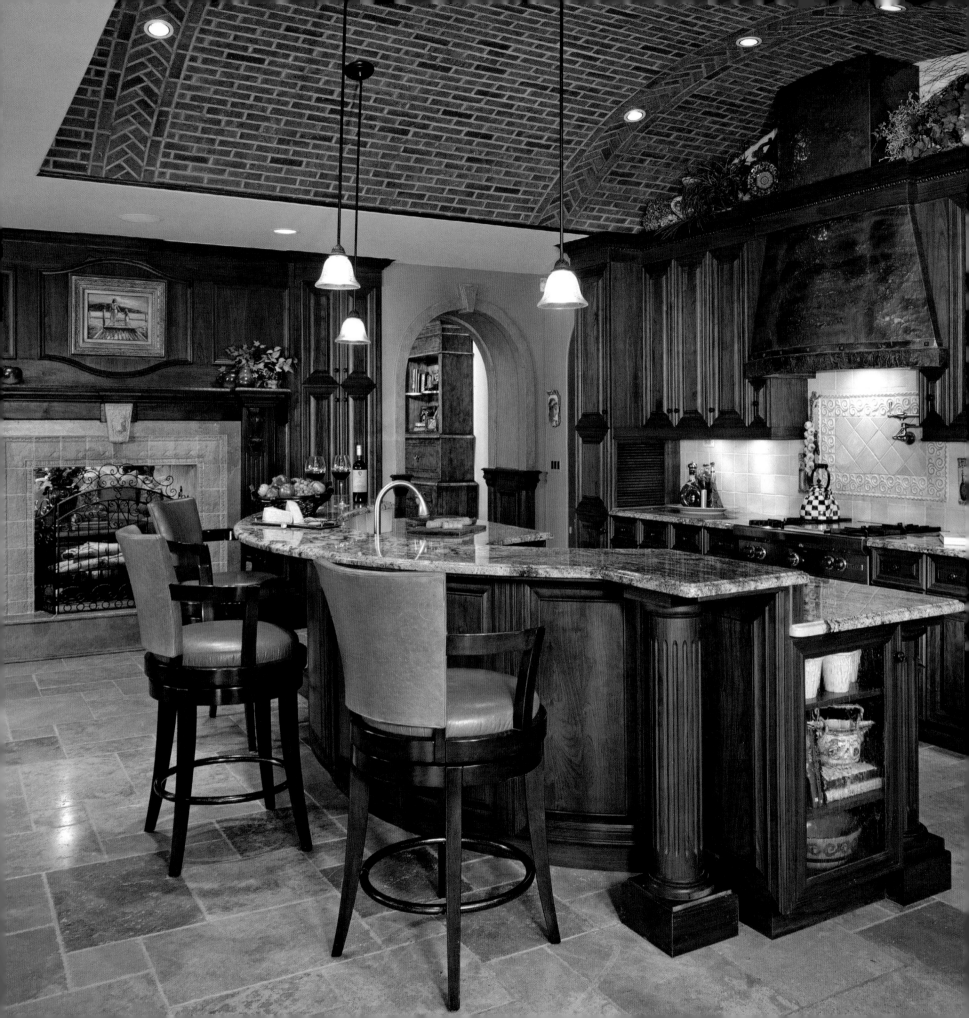

TIM O'NEILL & STEPHANIE HARRINGTON O'NEILL

O'NEILL HARRINGTON INTERIORS

Tim O'Neill and Stephanie Harrington O'Neill stand out in the crowded design world—not only for the quality of their work, but because the married interior designers are partners and maintain offices both in metro Detroit and neighboring Windsor, Ontario.

Stephanie grew up in Birmingham, MI; Tim grew up in Windsor. They met when both were studying for the American Society of Interior Designers (ASID) exam in downtown Detroit. Eventually, they married, set up a joint design business and flipped a coin where to establish residency. Windsor won.

"While we currently live in Windsor, our residential and commercial design work regularly takes us throughout metro Detroit, Windsor and as far as Toronto," says Tim. "The great thing about being versed in both countries and having access to resources in both is that we're able to offer our clients things they don't see everywhere else." Their partnership works, they say, because they're strong in different aspects of the business.

"Tim likes the building process and is really amazing with the architectural part of the business," says Stephanie. "I like color, accessories and the finishing details.

Tim also likes new construction, I prefer renovations." "It's a yin-yang thing," explains Tim. "We really complement each other—and our clients definitely benefit from it."

Despite their differences, both believe in timeless, quality design.

"Our clients' tastes reflect an eclectic mix, from traditional to contemporary to period styles," they say. "We don't follow trends. Trends fade. Style is eternal."

ABOVE
It took artist Lorraine Steelie one year to render this stunning mural depicting the clients' favorite European travels. A walnut and bronze iron staircase anchors this grand foyer entrance.
Photograph by Beth Singer

LEFT
Old World stone graces the floor surface of this magnificent custom-crafted walnut kitchen. A hand-wrought hammered copper hood floats above the cooking surface. The brick barreled ceiling crowns this setting making it a warm gathering place to welcome both family and friends.
Photograph by Beth Singer

O'NEILL HARRINGTON INTERIORS
Tim O'Neill
Stephanie Harrington O'Neill
512 South Washington, #299
Royal Oak, MI 48067
519.979.6660

CYNTHIA S. OHANIAN

CYNTHIA S. OHANIAN INTERIORS

ynthia Ohanian believes in beautiful colors, elegant, well-designed interiors and ageless design. She also believes in gracious living and strives to help clients create and enjoy a harmonious home and life.

"Our business is built on integrity, empathy and high standards," she says. "We steer the client toward good design because a good design is timeless. You cannot get tired of well-designed pieces. We compose the symphony according to the client's lifestyle and desires. I never repeat myself because each client is different, with different needs and loves."

An interior designer for 28 years, she prefers feminine colors, painted walls and 18th century French and English design. An ASID member, she volunteers for a wide variety of ASID-supported charities and often designs rooms for charity showhouses. Her work encompasses sites in Michigan, California and Florida, including golf course clubhouses and churches, and she has been widely published.

"Upon completion, the project stands on its own as a reflection of the client's individual personality and lifestyle," she says. "I cherish the time my client and I spend together and share in the joy of solving problems and creating beauty as a team. My goal is to achieve function while creating a beautiful environment. The highest compliment is when a client tells me 'I love my home.'"

ABOVE

The grand sweeping staircase sets the tone for this elegant, traditionally styled home. The carpet continues the home's raspberry, blue and floral theme off the foyer. The blue border on the stairs repeats the blue of the rug in the living room and raspberry flowers in the dining area rug. It provides interest and relief to the marble floors.
Photograph by Beth Singer

LEFT

This sizeable room serves as a dining and living room. To visually separate the two functions of the room, the Stark artist and I designed a rug with a rosette dividing the dining room from the living room. A coffered, beautifully designed ceiling has been installed, like the castles of Europe. The large Venetian windows overlook a superbly landscaped yard, as well as a scenic lake. The generous space is warmed up by lovely chintz on the sofa and plaid for the ottoman We installed panels on the walls and painted them the same yellow as the rug. With the two chandeliers lighted at night, the effect is luxurious and romantic.
Photograph by Beth Singer

CYNTHIA S. OHANIAN INTERIORS
Cynthia S. Ohanian, ASID
37000 Woodward Avenue, Suite 101
Bloomfield Hills, MI 48304
248.647.7890
Fax: 248.647.0526

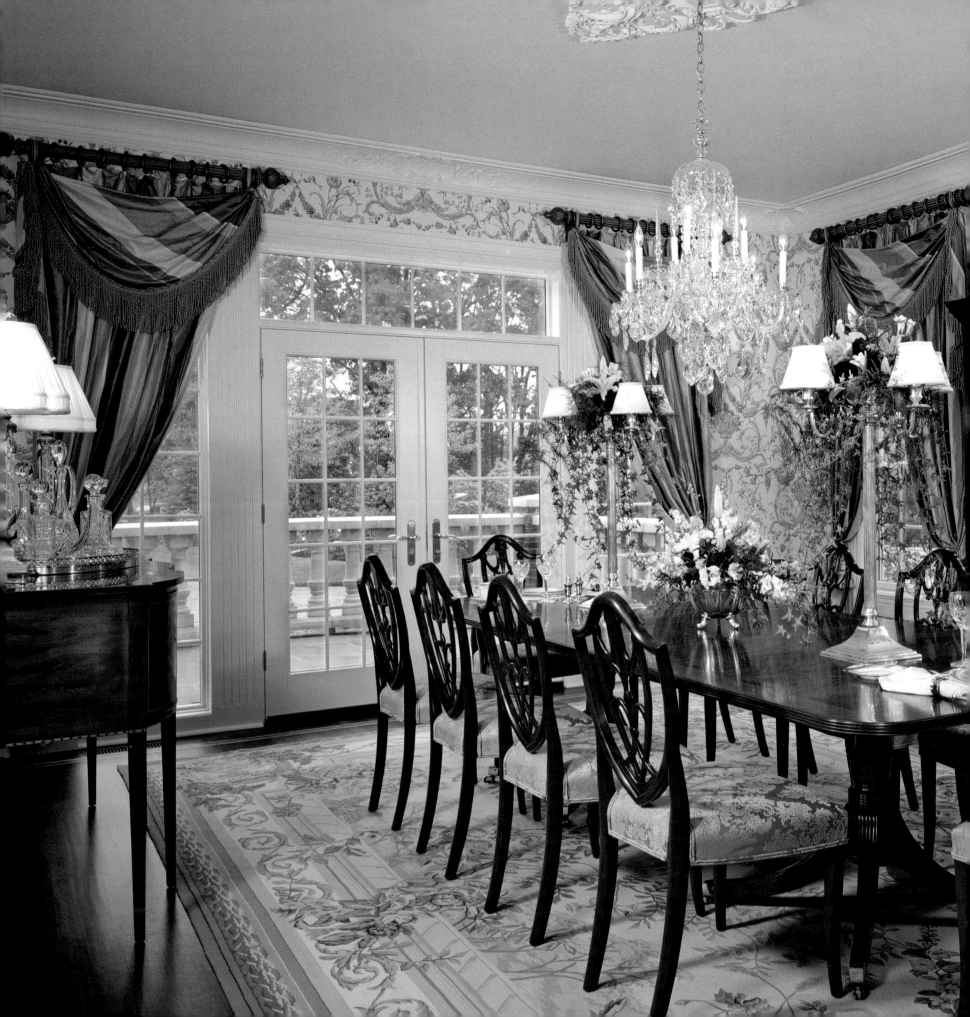

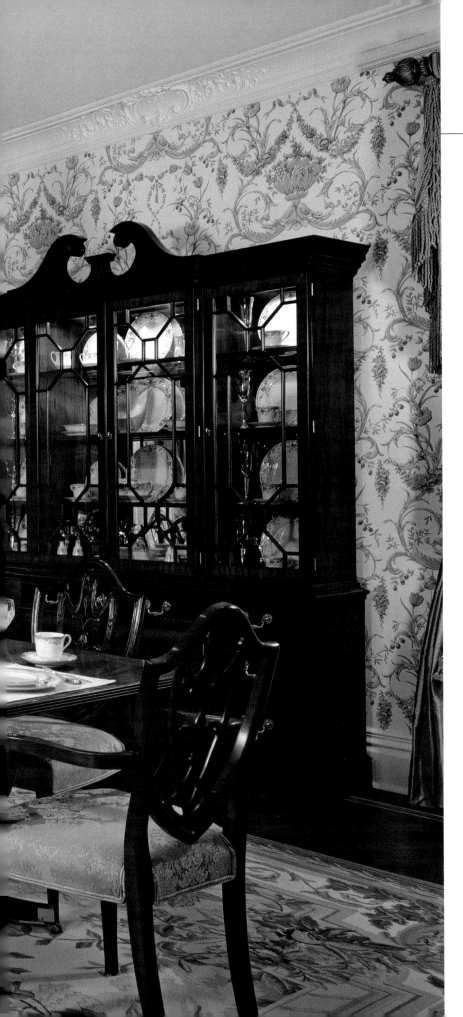

GEORGE A. PAVICK
PLEATS INTERIOR DESIGN

George A. Pavick of Pleats Interior Design came to his design career through the back door—or rather, through the window. Pavick, who grew up in Ohio, has worked for more than 20 years in all aspects of the design field, including tile, carpet, wallpaper and window design. It was his work in Ohio with custom window treatments that lead him to found Pleats Interior Design in 1989. He later moved that business to Lansing, Michigan where the 4,200-square-foot showroom remains a fixture in the city's Old Town neighborhood.

While Pavick still does windows, they're only a small part of his business today. His extensive client base takes him throughout Michigan and Ohio to as far away as California, Florida and Texas. "We support our clients wherever they need us to go," he insists.

His favorite projects are new construction, "from the blueprint all the way to final accessorizing," he says. "When you start with blueprints, you can make any necessary changes before construction begins. That also allows more design freedom for the finished project."

Seen on these pages are two special East Lansing homes. The dining room, seen here, was "part of a special project for a unique client," Pavick says. Highlights of the

LEFT
The hand-woven silk draperies and solid mahogany furniture in this East Lansing dining room lends itself to a formal feeling. Seating for 14 makes this room very functional as well as elegant. The French door opens to a charming front veranda.
Photograph by Beth Singer

| 103 |

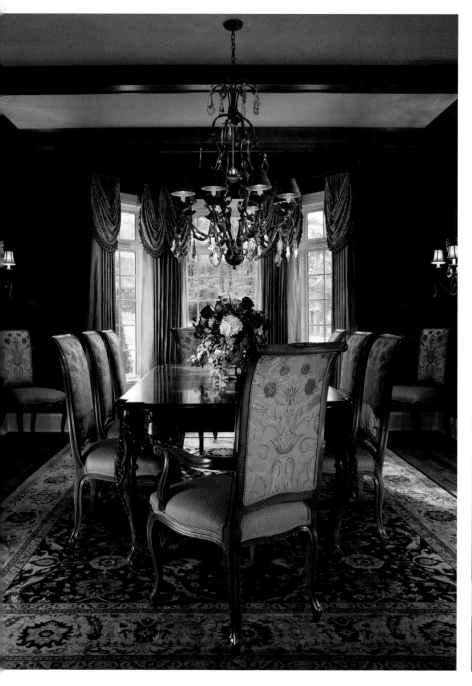

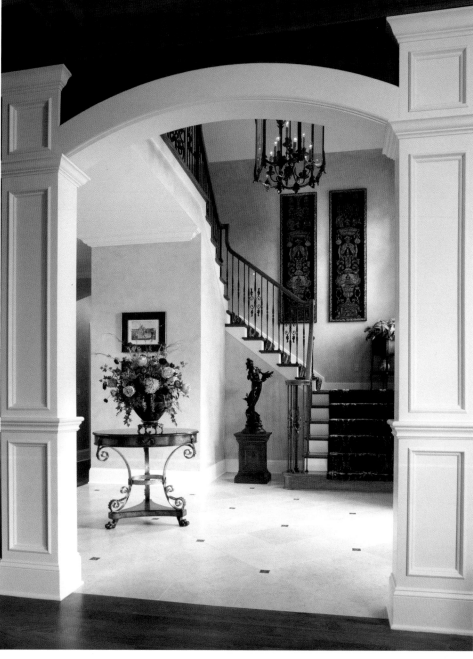

Georgian residence include a large foyer, a dining room that seats 14, a spacious library/ sunroom, even a third-floor turret.

Wherever he travels, the basics of good design remain the same, he says. Pavick believes a home must reflect its owner, and he often incorporates a piece with deep meaning to the homeowner, whether it be artwork, a family heirloom or even needlework made by a relative.

"I like a room to look like it has always been there and to have a timeless feel," he says. "I truly believe in giving a client what they want and need. I like to create environments that have good basic design elements and stand the test of time."

ABOVE LEFT
In another East Lansing dining room, Venetian plaster walls in rich red and gold tones surround the burled walnut table giving a feeling of relaxed elegance. Silk window treatments hang from hand-braided wrought iron rods.
Photograph by Beth Singer

ABOVE RIGHT
Jerusalem gold honed lime stone flooring with bronze inserts welcome the guest into the two-story foyer. Glazed walls soften the mood leading to the custom wrought iron staircase. The bronze inserts were the client's special find.
Photograph by Beth Singer

FACING PAGE
In this powder room a burled walnut chest was transformed into a vanity with Rosso Damascus marble. Hand-painted wall paper finishes off the room with elegance.
Photograph by Beth Singer

MORE ABOUT
GEORGE...

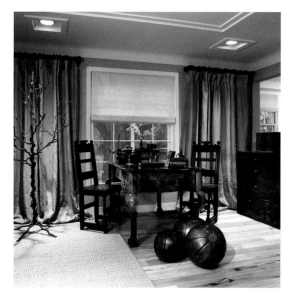

The daughter of cultural anthropologists, Leslie Ann Pilling's childhood was anything but conventional. Her summers were spent in Northern California, just off a Native American reservation. Antiquing all over the country was a favorite family activity. "My parents instilled in me a real appreciation for history and preservation," says Pilling, an accomplished artist, fine jewelry designer and one of Michigan's top interior designers. "I can creatively incorporate design elements from different time periods and create a home interior that's truly reflective of the person who lives there." With degrees in education, art and psychology, Pilling often jokes that she's a home décor therapist for her clients—a trait that served her well when she opened the antique and accessories boutique, Presence II, in downtown Birmingham, Michigan.

Pilling's interiors include contemporary and traditional. She also works in home interior and retail store layout and design. She has completely renovated an 1855 historical farmhouse, made children's fantasies come true with magical transformations of their bedrooms and playrooms, and is an expert in kitchen and bath design. Several of Pilling's clients' homes have been featured on prestigious home tours including the American Institute of Architects (AIA). Pilling has a keen knack for taking found, everyday objects and producing functional and creative results. She took 21 hand-carved serving plates that she picked up at a clearance outlet and had them made into a stairway banister. She took ordinary crystal cabinet knobs and turned them into decorative powder room faucet handles.

The home featured in this article spotlights an eclectic mix of antique and contemporary details from America, Asia, Italy and France. The living room is accented with original Asian wallpaper from a turn-of-the-century Paris boutique. Furniture includes a burled wood partners' desk, hand-carved walnut chairs and a Tansu chest from Japan. "I love a challenge," says Pilling. "Clients demand design that is unique. And why shouldn't they?"

ABOVE
This elegant and comfortable partners' desk is enjoyed as a game table.
Photograph by Beth Singer

LEFT
An exquisite living area, with multi-cultural elements, is grand yet still very inviting.
Photograph by Beth Singer

LESLIE ANN PILLING DESIGN/PRESENCE II
Leslie Ann Pilling
3810 Mystic Valley Drive
Bloomfield Hills, MI 48302
248.723.9770

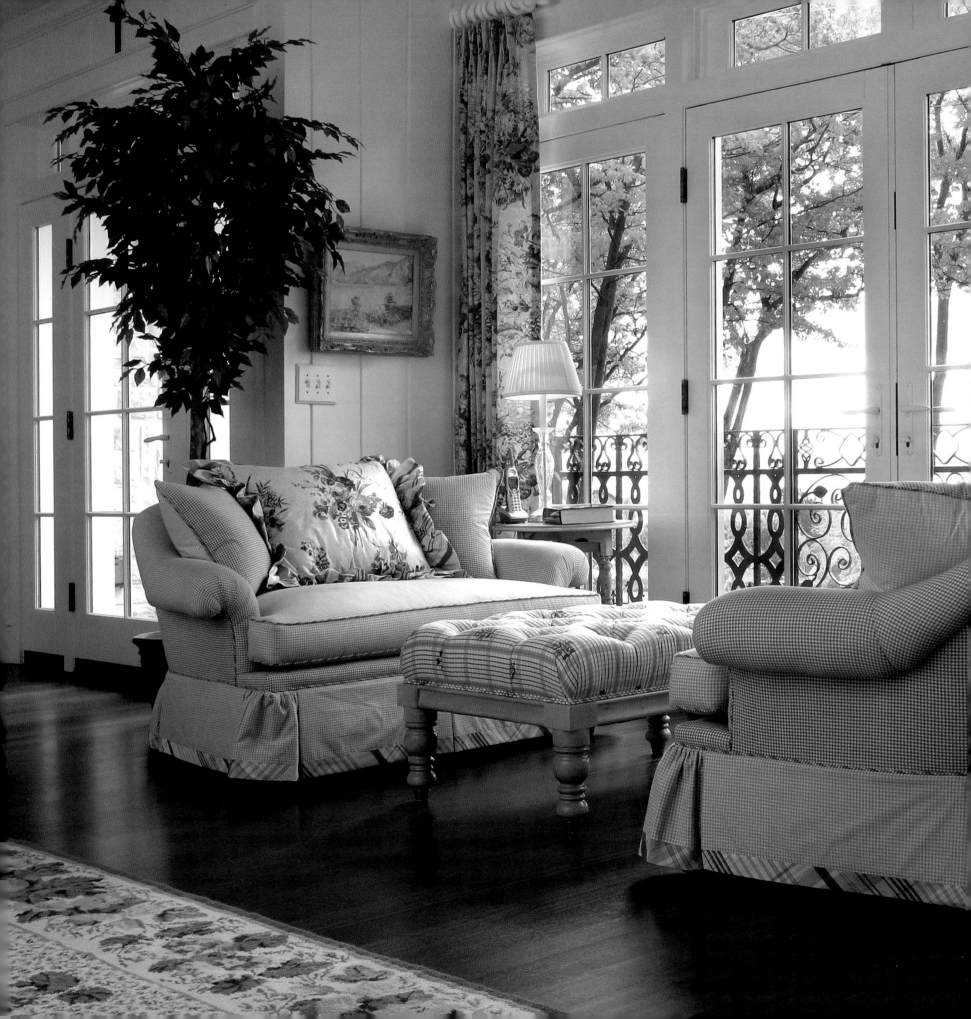

WENDY REEVE
COTTAGE INTERIORS

E ven as a child, Wendy Reeve dreamed of a career in interior design. "I remember looking at a Sears catalog in the 4th grade and turning to the girl next to me and telling her that I was going to be an interior designer," she says. Years later, that dream has become a reality. Reeve's design firm, Cottage Interiors, is flourishing in Harbor Springs with a staff of two: Reeve and Amy Rifenberg, another interior designer.

Reeve grew up on a small family farm in the Lansing area and moved to Northern Michigan directly after graduation from Albion College. "I had always wanted to live Up North and started practicing in my chosen field almost immediately. I was lucky," she says. Reeve initially worked as a kitchen draftsman/designer before spending 12 years as a staff designer with a Petoskey firm. She founded Cottage Interiors six years ago. Today, the firm is best known for traditional style with a twist. "We like interiors that are warm, inviting and not too formal," she says. "Color is important to us and should be clear, fresh and unabashed. We dislike muddy, grayed colors or fabrics that look like they were laundered once too often."

Reeve believes beautiful colors and beautiful fabrics make the difference. "Find the one fabric or wallpaper you can't live without and build around it, using it as simply as possible," she advises.

LEFT
Tete-a-tete with a view over Little Traverse Bay. The sofas are covered in Cowtan & Tout, Scalamandre & Lee Jofa. Draperies are Lee Jofa. The area rug is custom designed by Wendy and custom made by Vermilion.
Photograph by John Wooden Photography

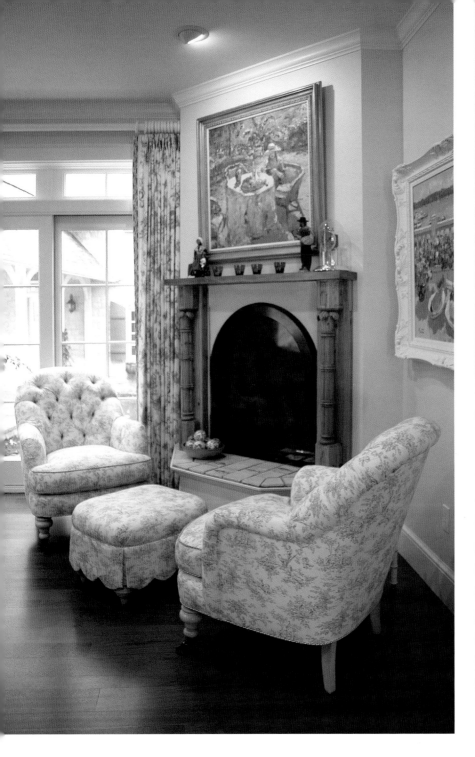

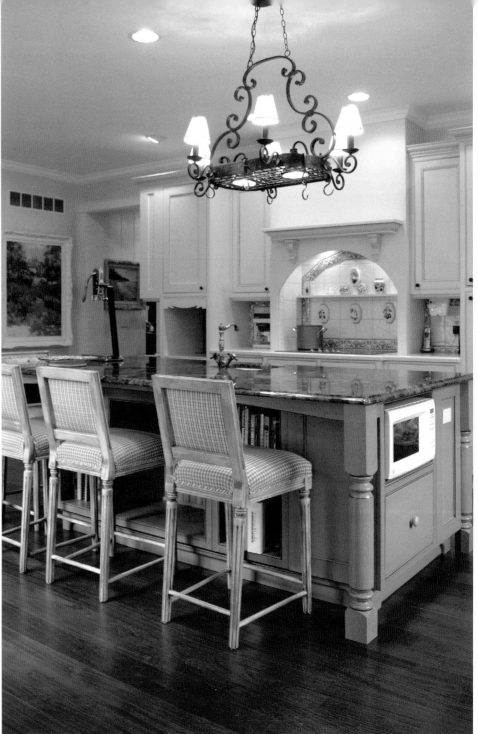

Twenty years later, life in the North has been everything she hoped for—and more. "Everyone here is open, friendly and trusting," she says. "Our clients all become good personal friends."

"Cottage Interiors is dedicated to providing any service our clients desire because most of them are not in this area year-round," she says. "And, as we are four hours north of the Detroit Design Center, we are committed to possessing the best fabric and wallpaper library suited to our needs. "We don't want to be the biggest design firm in the area, only the best," she says.

ABOVE LEFT
The reading corner of the kitchen has a Pierre Bittar painting over the fireplace of the homeowner at an alfresco lunch in the south of France.
Photograph by John Wooden Photography

ABOVE RIGHT
This kitchen was custom designed by Cottage Interiors. The cabinetry is North Country Cabinets of Petoskey, chosen for their custom finishes and construction.
Photograph by John Wooden Photography

FACING PAGE LEFT
This master bedroom has a spectacular view over Little Traverse Bay. The chairs and drapes are Beacon Hill and the upholstery is by Pearson.
Photograph by John Wooden Photography

FACING PAGE RIGHT
The background for this spectacular Williamsburg bed is the B&F wallpaper with Carleton draperies and the hand-painted silk pillows on the bed. Everyone loves a blue room.
Photograph by John Wooden Photography

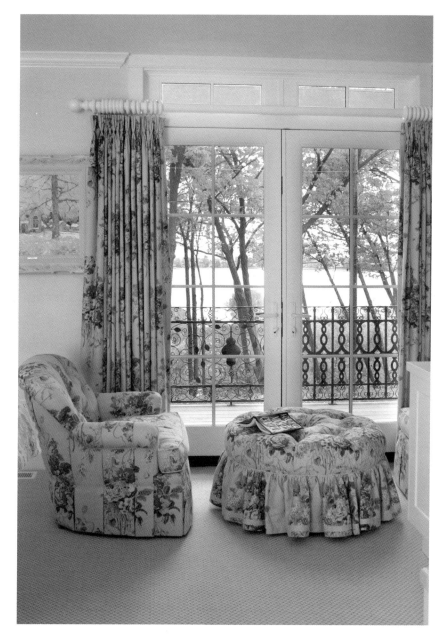

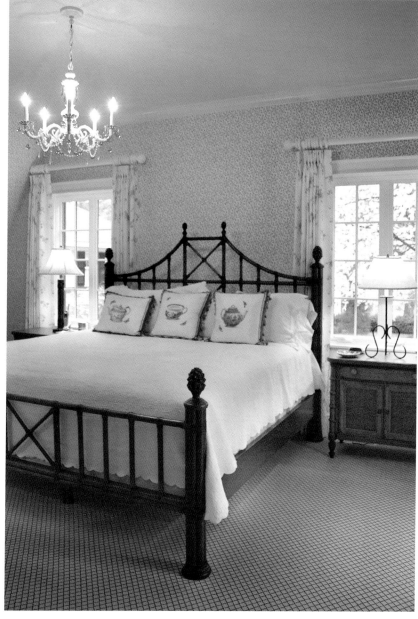

MORE ABOUT WENDY...

Modern. It has no soul. I can't tell good from bad. It all looks bad.

Paint the walls a beautiful color, something you would like to live with every day.

Hard-cover fiction books, potato chips and tennis. I'm an avid tennis watcher and player

If I don't die clutching a fabric sample, it will be a tennis racquet in my hand.

COTTAGE INTERIORS
Wendy Reeve
334 State Street
Harbor Springs, MI
231.526.1729
Fax: 231.526.1731

Arturo Sanchez & Barry Harrison

ART-HARRISON INTERIOR DESIGN STUDIO

"Our goal is to create a home that's the design equivalent of the little black dress," says Arturo Sanchez and Barry Harrison of Art-Harrison Interior Design Studio. "Our overall aesthetic is classic and timeless, but we believe in shaking things up a little. We might use an amazing antique mirror in an extremely modern home and believe that unexpected touches are what makes an interior interesting."

Now in their 12th year of business, the innovative duo stands out in a crowded design world. Best known for their custom work, they're involved in every step of the process, from the design through its production and final placement in a client's home.

Art-Harrison clients benefit from having two sets of eyes and ears, as well as two sets of ideas.

"We don't miss a detail," says Arturo. "Barry is the more physical one, always busy in the studio carving or painting. I'm nurturing, more involved with clients and in handling the day-to-day business operations. We're both very hands-on in our own way." While different, they both believe that art is key to a truly personal interior.

"We have a strong appreciation for art, especially emerging young talent," says Barry. "Detroit has a vibrant art community, and we act as an insider's guide for them, not only here in Detroit, also in all of the other cities we visit and work in. We love seeking out unknown galleries and shops and mixing and matching art and furnishings for our clients to create a look that's uniquely theirs."

ABOVE
The design of this room revolves around the use of saturated color to create comfort and warmth. Examples of our custom furnishings can be seen in the buffet, small footstool and the wool and silk rug.
Photograph by Beth Singer

LEFT
This living room was designed to be used predominately for evening entertaining and was the 2005 Detroit Home Awards Winner for "Best Use of Art & Antiques in an Environment."
Photograph by Beth Singer

ART-HARRISON INTERIOR DESIGN STUDIO
Arturo Sanchez
Barry Harrison
4339 Delemere Boulevard
Royal Oak, MI 48073
248.549.1003
Fax: 248.549.1006

MARGARET SKINNER

MARGEAUX INTERIORS, INC.

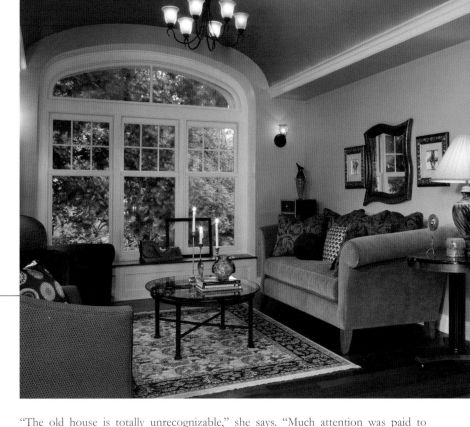

When Margaret Skinner was little, her mom called her Margeaux. Years later, she discovered the joys of French wine Chateau Margeaux, and chose the name Margeaux Interiors for her budding interior design business. In business since 1998, she studied interior design and art history at the University of Michigan. Based in Birmingham, Skinner works with clients throughout metropolitan Detroit, including Bloomfield, Birmingham, Northville and Ann Arbor. Wherever she works, however, she prefers spaces that are classic yet uncluttered. "I like rooms to be warm, to be mixed with different textures, and reflect my client's personality."

Her projects vary in size, from consulting, to full-scale remodeling and new construction. "Sometimes the project just involves color selection and materials," she says. "I'm always amazed at how many people have trouble with paint color. They agonize over it." That's where she comes in. "I find that clients want one answer on how to do something, when the reality is that there's more than one way to do almost anything. As designers, our role is to help eliminate the confusion and make the best decision." She has new empathy for clients after recently remodeling her former 1,300-square-foot, 1950's cinder block ranch into a 3,200-square-foot, stone Tudor-esque cottage.

"The old house is totally unrecognizable," she says. "Much attention was paid to the architecture, the millwork, the lighting, but we also reused original materials." Like her business, the home features classic design. "It really is the details," she says. "Renovating my home has given me a new appreciation for the process. I've recently received my builder's license, so I can better assist my clients and tradespeople through the experience. After all, it really helps if you speak the language."

ABOVE
The barrel vaulted ceiling highlights the arched window. Ambient lighting adds warmth to the eclectic seating area.
Photograph by Beth Singer

LEFT
Contrasting wood tones and granite complement the Shaker style. Detroit-produced Pewabic tiles accent the backsplash.
Photograph by Beth Singer

MARGEAUX INTERIORS, INC.
Margaret Skinner, Allied Member ASID
335 E. Southlawn Boulevard
Birmingham, MI 48009
248.915.8222
www.margeauxinteriors.com

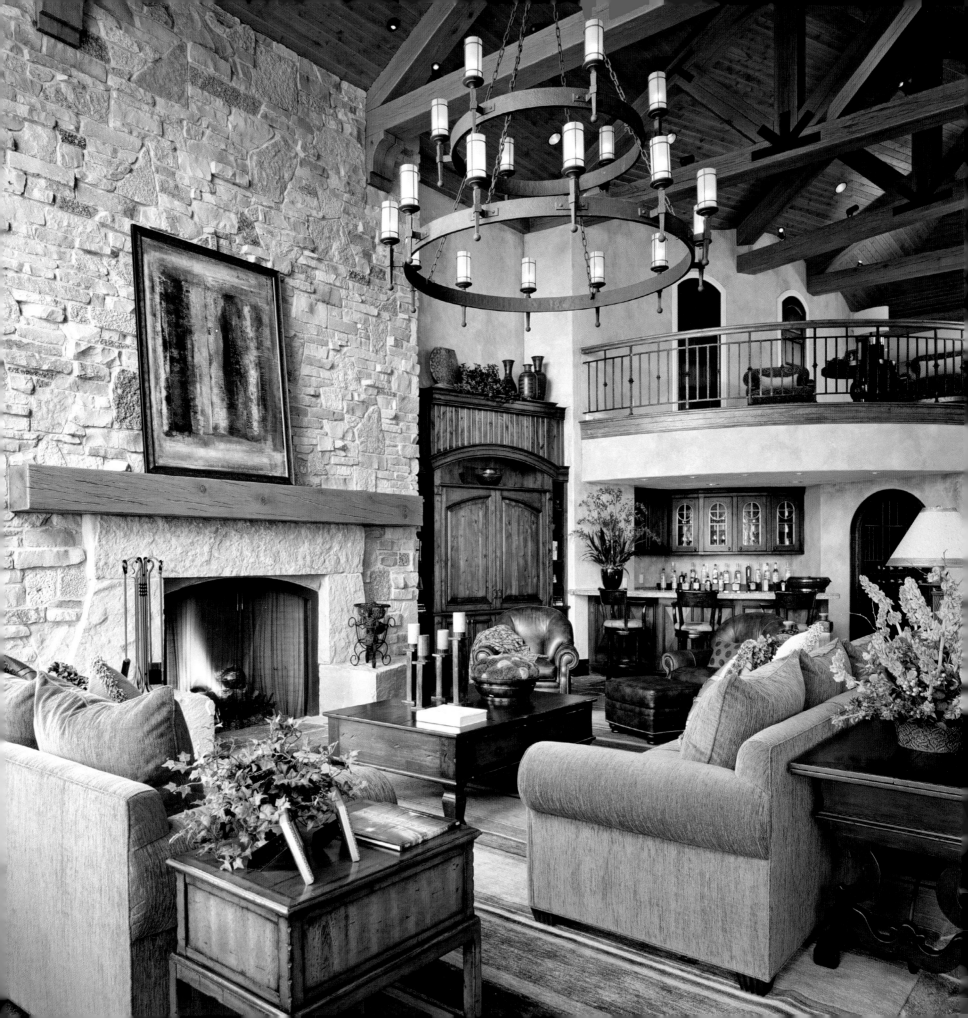

LISA SKOCELAS

LUBIN, SCHULZ & SKOCELAS

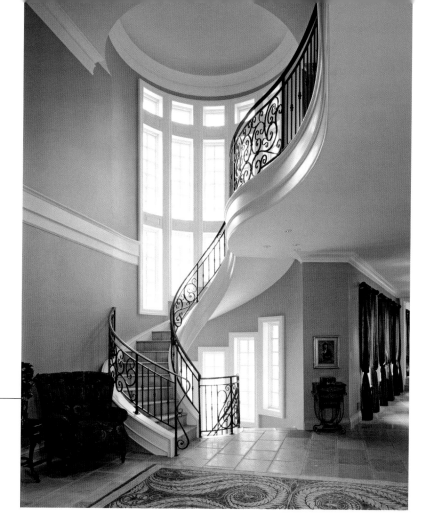

Unlike many interior designers, Lisa Skocelas has a master's degree in architecture. This provides a complete, whole-house perspective that necessitates her involvement in all stages of a residential project and her view of a home as more than just the sum of its parts.

"Being involved from initial conceptual drawings to selecting the last accessory is exciting," she says. "I enjoy all aspects of the design field."

A partner with Lubin, Schulz and Skocelas, a Bloomfield Hills architectural firm, Lisa advises clients on everything from moldings to linens. Furniture, cabinetry, fabrics and decorative details are part of her extensive repertoire. A history buff and avid preservationist, she often draws inspiration from the past.

"I've always been interested in history and would love to travel back in time," she says. "My dream job is to work on the restoration of an old European castle."

Closer to home, she accepts approximately 10 projects yearly and enjoys seeing a home designed from start to finish.

"When designing and creating living spaces, the end product should portray my clients' tastes along with my design intent," she says. "I define as project a successful when the home reflects the personality and lifestyle of the homeowner."

ABOVE
Residence foyer staircase in Bloomfield Hills, Michigan.
Photograph by Beth Singer

LEFT
A vacation home's main living room in Bay Harbor, Michigan.
Photograph by Beth Singer

LUBIN, SCHULZ & SKOCELAS
Lisa Skocelas
2600 S. Telegraph Road #150
Bloomfield Hills, MI 48302
248.335.8877
Fax: 248.335.8852
www.lubinassociates.com

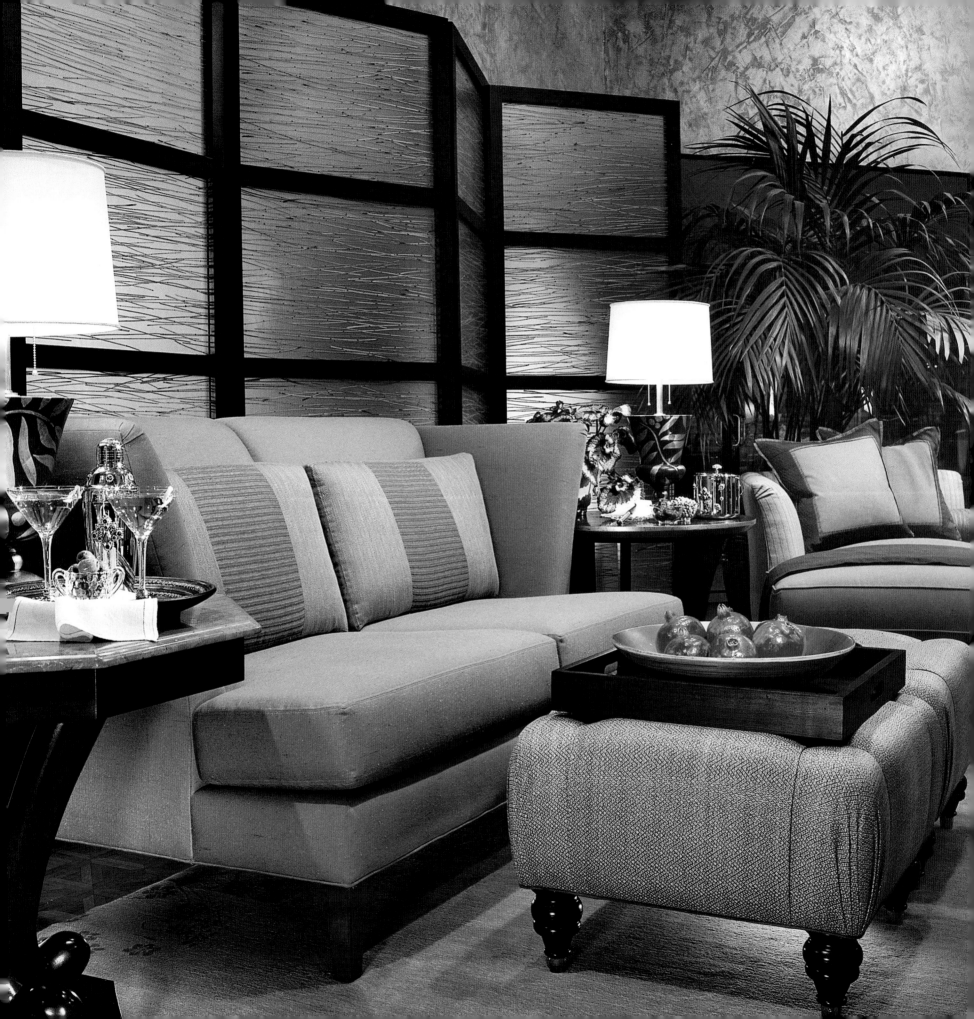

JENNIFER TAYLOR
JENNIFER TAYLOR STUDIO

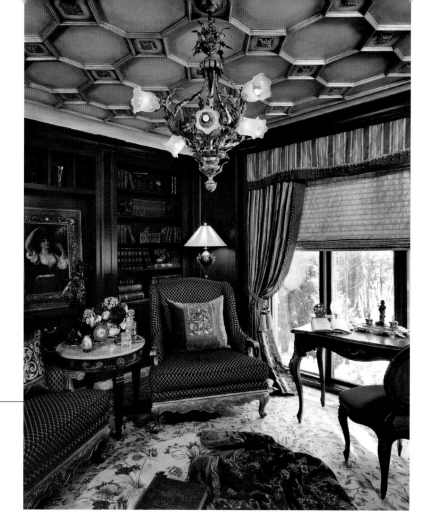

Jennifer Taylor's dream project would be restoring a villa in Italy using authentic materials and Old World craftsmanship. Jennifer appreciates handmade furniture, textiles and decorative objects and this appreciation fuels her fascination with antiques. She incorporates old architectural materials and antique furnishings into her projects whenever possible, as their imperfections create a textural character that cannot be achieved with new materials.

Jennifer's background includes concentrations in both art and design. She was awarded a scholarship to the Columbus (Ohio) College of Art and Design, where she majored in fine arts, focusing on sculpture. She received an interior design degree from Wayne State University in Detroit.

"My art background honed my drawing and illustration skills, enabling me to communicate my ideas more effectively. The study of sculpture has been invaluable in terms of having the ability to create serenity or tension simply by how I place objects within a space. It sharpened my sense of proportion."

She takes her color cues from nature. "How inspiring is the color of sun-dried wheat against a brilliant blue sky, or the 100 pastels found on a single seashell? Color combinations found in nature produce a striking effect when translated into fabric and paint."

"Everything chosen for a client's interior must be beautiful to the eye and wonderful to the touch," she says. "Providing sanctuary is part of my job. I strive for over-the-top comfort."

ABOVE
A classic combination of luxury, comfort and visual complexity, this formal room was designed to replicate the look of a turn-of-the-century gentleman's library.
Photograph by Jeff Garland

LEFT
Warm colors give Michigan interiors a lift. Fabrics the color of mango, curry and fushia combine with raffia, bamboo and rich woods to create a comfortable retreat.
Photograph by Beth Singer

JENNIFER TAYLOR STUDIO
Jennifer Taylor
676 Eleven Mile Road
Royal Oak, MI 48067
586.212.9907
jtstudio@netzero.com

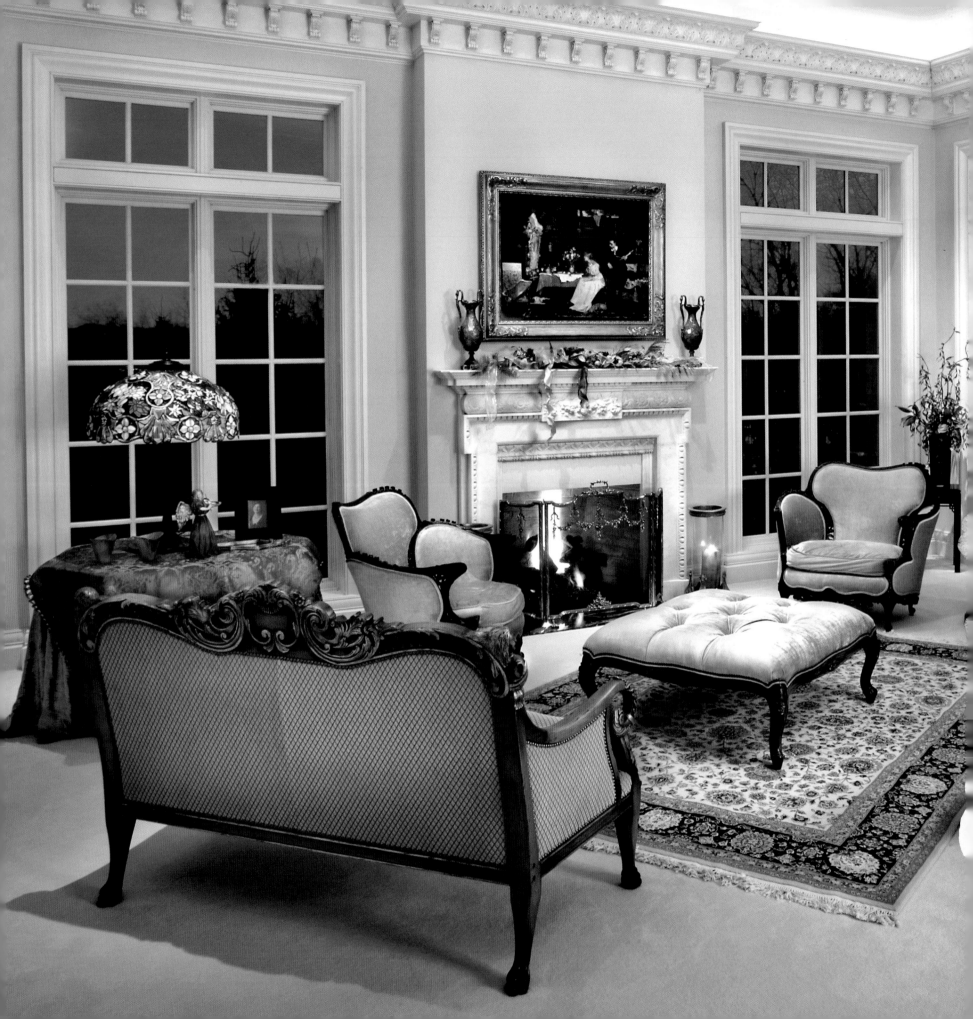

WAYNE VISBEEN

VISBEEN ASSOCIATES, INC.

Visbeen Associates, Inc. has been in the business of bringing architectural dreams to life since 1992. From custom-designed houses to entire neighborhoods, Visbeen offers clients personalized attention and outstanding full-service architectural, planning and interior design services. A registered architect and professional registered interior designer, founder Wayne Visbeen grew up in his father's construction business.

Visbeen Associates has several licensed architects and interior designers specializing in residential architecture. "Our team approach affords the best of service and talent to each of our projects, from design and design development to floor plans, elevations and construction drawings. Throughout a project, each portion is handled by the team member with the greatest strength in that area. Along the way, illustrations by a staff illustrator help the homeowner see exactly how the home will look prior to construction. These different disciplines align to create the finest finished project possible."

Visbeen and his team work to meet and exceed a client's specifications. "We try to tailor the experience to what makes the client most comfortable," he says. "Most of our clients enjoy being a part of the actual design experience."

That experience starts with a lifestyle interview, covering questions about every area of the home, from function to aesthetics. During the interview, Wayne often begins sketching and taking notes, producing 3-D drawings along the lines of what the client describes.

LEFT
The indirect uplighting and 14' ceilings of this elegant living room help provide a grand, open feeling. The eye is drawn to the 19th century antique white Italian marble fireplace, crowned by an 1883 Karlovsky-Berci-Paris painting. Opulent touches such as plaster cove, corbels, moldings and ceiling details add authenticity. Carved marble sculpture by Eugene Modeste Edmond Lepoittevin, a well-listed Parisian artist, 1859.
Photograph by William J. Hebert

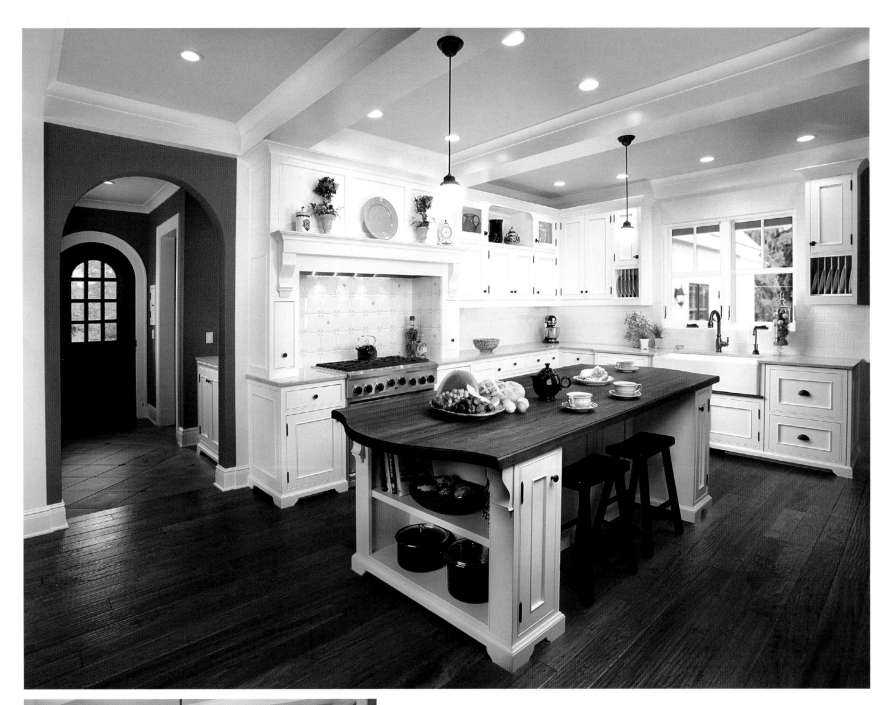

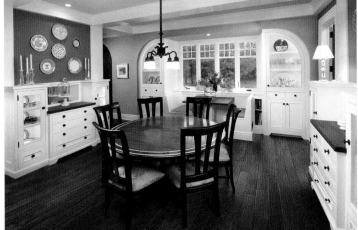

ABOVE & LEFT

The carefully crafted kitchen in this home was designed to recapture the form and function of an American kitchen from the early 1900s. It functions well because of the efficient work triangle and abundant counter space for both preparation and presentation. The warmth of an old-fashioned kitchen was achieved with solid walnut tops on the island, built-in serving buffets, and a cozy bay window booth. Access to the rear patio allows the owner to easily dine alfresco. With wide beamed ceilings, hand-hewn Brazilian cherry flooring, hand-glazed tile, a pair of antique arched china cabinets, built-in cappuccino maker and the large porcelain farmhouse sink, this kitchen melds the best of the past and present.
Photograph by William J. Hebert

FACING PAGE TOP

Taking on a decidedly masculine flavor, the rich woods of this entertainment room including barrel-vaulted, maple wood tongue-and-groove ceiling, and mahogany columns add genteel class. The 40' long Notre Dame hand-painted mural adds an incredible focal point.
Photograph by William J. Hebert

FACING PAGE BOTTOM

The perfect entertainment room for the avid sports fan. A built-in home theater with multiple screens, which open to a game room, ensures no important game is missed. A handsome maple tongue-and-groove barrel ceiling adds to the overall rich feeling of the room. The tone of the room is set with a stunning 40' long Notre Dame hand-painted mural.
Photograph by William J. Hebert

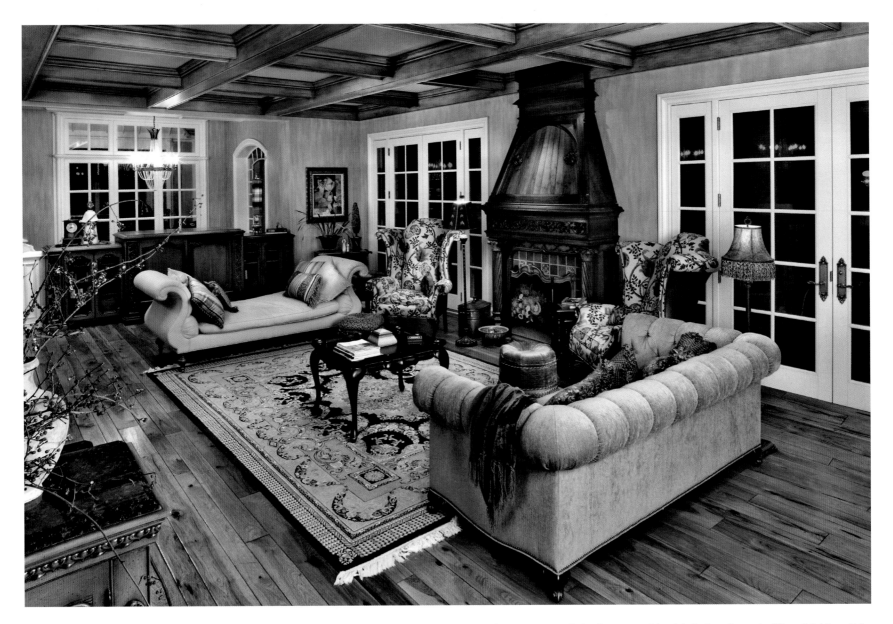

He will later develop conceptual floor plans, interior and exterior sketches, putting rooms and details together.

"The end result is homes that are as functional as they are beautiful and clients that are incredibly pleased. That's what's most important to us," he says.

Visbeen says the firm works in a variety of architectural styles. "If we have a style, it is whatever is right for the client," he says. "We research any architectural style the client requests and develop it to its fullest potential. We'll create a floor plan that exactly fits our clients' family needs and lifestyle while designing a beautiful and functional home.

Visbeen has received many awards for architecture and interior design and has been published in numerous local and national publications, including *Home, Residential Architect* and *Better Homes & Gardens*. He says the company will continue to focus on both custom homes and neighborhood developments in the future.

"We've become one of the largest residential design firms in West Michigan," he says. "With almost 15 years experience and more than 400 homes under our belts, we will continue to be a valued partner for both developers building custom homes and individuals looking to build their dream home."

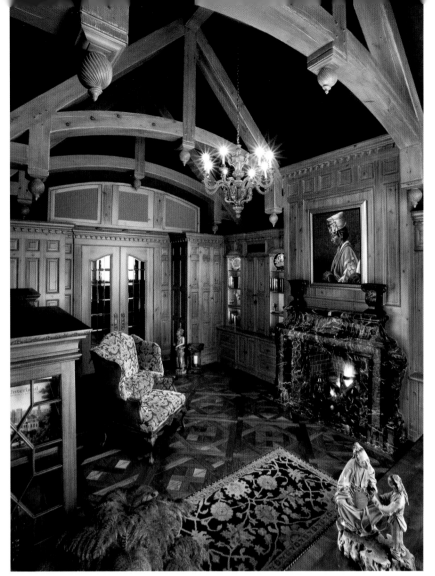

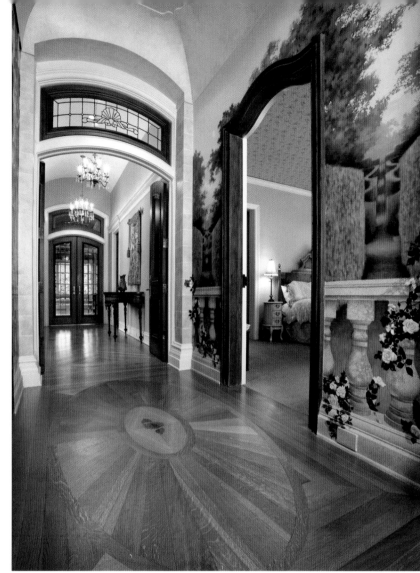

MORE ABOUT WAYNE...

WHAT SIZE IS YOUR COMPANY?

Since our inception in 1992, the firm has grown to include eight employees, all of whom are critical to our continued success.

DESCRIBE YOUR STYLE OR DESIGN PREFERENCES.

The firm is known for a wide variety of architectural and interior design styles, however, the common element is the incredible attention to detail and organization, whatever the style.

WHAT SEPARATES YOU FROM YOUR COMPETITION?

The incredible depth and talent of our team.

VISBEEN ASSOCIATES, INC.
Wayne Visbeen, AIA, IIDA
4139 Embassy Drive SE
Grand Rapids, MI 49546
616.285.9901
www.visbeen.biz

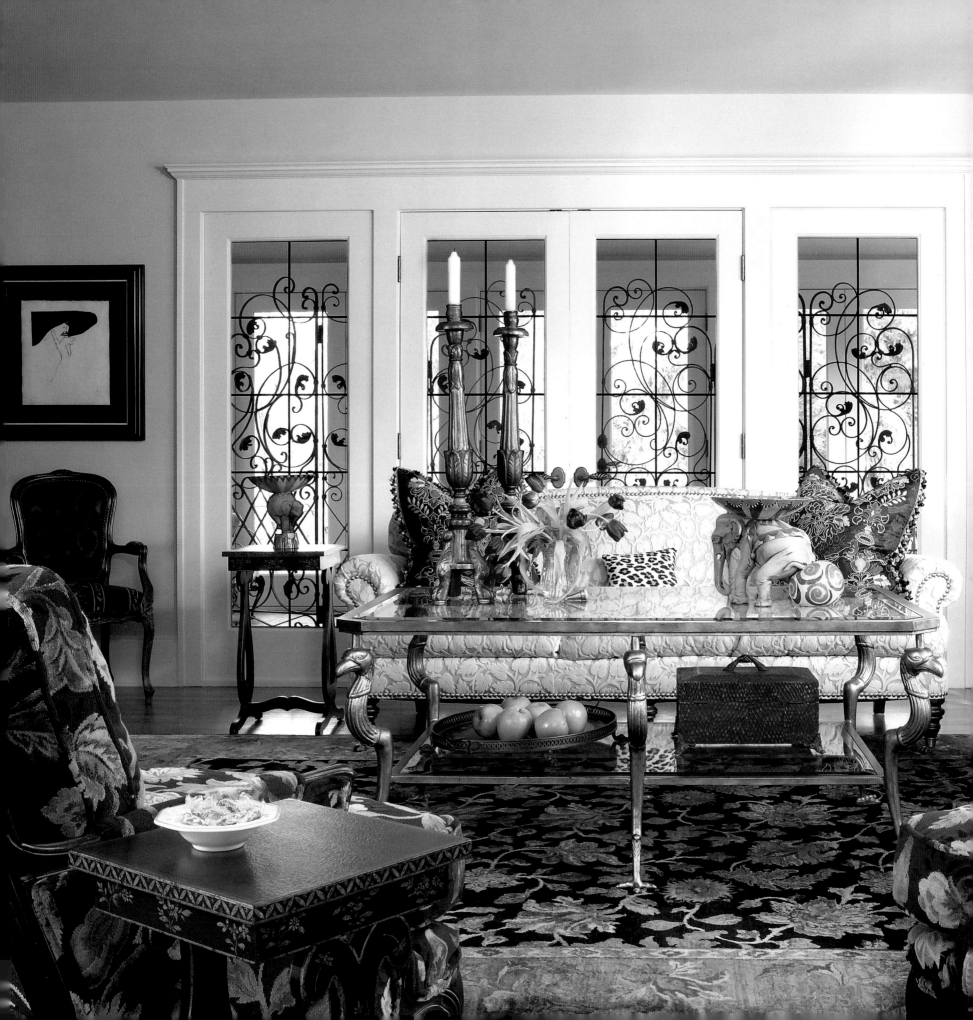

With a thriving design business spanning 20 years, P.J. Whitehead is known for elegant interiors integrated with a frank sense of comfort. Her belief is that both interior and exterior spaces ought to give visitors a feeling of genuine hospitality.

Careers in fashion design, window dressing and interior design have helped P.J. develop a unique design philosophy. She believes that no two projects should ever be the same and that every project should have a drop-dead entry that has a "wow" impact and gives viewers a sense of what the rest of the house will be like. "One significant piece can set the personality for the entire room or even the entire house," she claims. I like to include antiques to give a room a focal point and sense of history."

The firm specializes in the art of arrangement, expertly integrating architectural details, furniture and accessories into unparalleled interiors. With services that range from one-day makeovers to complete design services for the entire home, P.J. Whitehead's interprets clients' needs and desires and turns them into captivating interiors. "We pride ourselves on giving projects a unique combination of beauty, warmth and function," she says.

The firm recently moved to a new Birmingham location and is proud of its 1,400-square-foot warehouse space and design studio's gallery for the home. PJ says, "It's very eclectic, with a little bit of everything, from fine antiques to vintage French posters."

ABOVE
As the entertainment nucleus of the home, the custom bar with onyx counter top and china cabinet, filled with vintage cocktail glasses, acts as a link between kitchen and dining areas.
Photograph by Beth Singer

LEFT
A vintage poster by Capiello sets the tone for this great room with its bold red and gold colors mirrored in the fabrics. A mix of old and new furnishings as well as pattern and texture add to the daring design.
Photograph by Beth Singer

P.J. WHITEHEAD'S INTERIOR ARCHITECTURE & DESIGN
Phyllis J. Whitehead
2279 Cole Street
Birmingham, MI 48009
248.645.1410

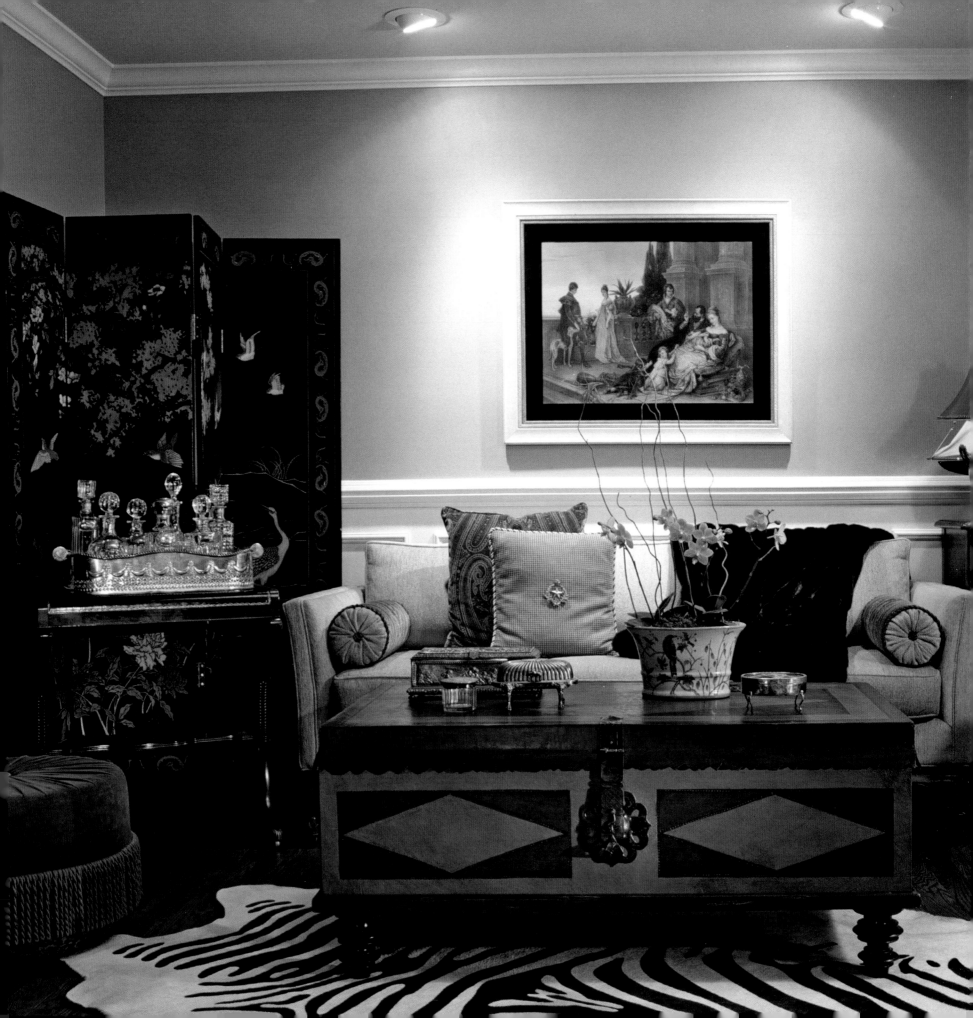

ELIZABETH WOLFF

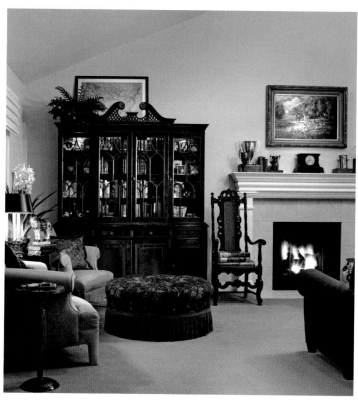

Elizabeth Wolff has a penchant for vintage books. They find their way not only into her home, but also into those of her clients. "Beautiful old books have always fascinated me," she says. "I love their bindings, personal inscriptions and their bookplates. I have also always loved their aged patina." Books, 19th-century English antiques and other vintage pieces are a big part of her personal style, she says.

She recently moved into a new home and is enjoying creating a truly individual design through her much-loved collections. "My house is definitely a mix of carefully chosen pieces," she says. "I love vintage Baker furniture, old globes and unique pieces with character." Using unexpected pieces in unexpected places—a garden statuary in the great room, for example—is part of her style. "I always try to incorporate my client's taste, collections and uniqueness into the end result," she says.

"I love what I do. My passion is definitely traditional, but contemporary interiors are a refreshing change."

ABOVE
Trophy and antique box collection rest on the mantel while a charming, mid 19th-century-chair is placed next to the fireplace. A rich mahogany china cabinet is used as a bookcase. Above the bookcase is framed a "Principal Explorer's" map from 1808 (original).
Photograph by Beth Singer

LEFT
Above this living room sofa is a framed antique print made from a steel engraving. Adding interest, a collections of vintage decanters are placed on the end table. The coffee table is actually a tooled leather trunk by Milling Road (Baker). Assortment of antique boxes on coffee table.
Photograph by Beth Singer

ELIZABETH WOLFF DESIGN
Elizabeth Wolff
6425 Worlington Road
Bloomfield Hills, MI 48301
248.626.9976
ewolff2004@aol.com

THE PUBLISHING TEAM

Panache Partners, L.L.C. is in the business of creating spectacular publications for discerning readers. The company's hard cover division specializes in the development and production of upscale coffee-table books showcasing world-class travel, interior design, custom home building and architecture, as well as a variety of other topics of interest. Supported by a strong senior management team, professional associate publishers, and a top-notch creative team of photographers, writers, and graphic designers, the company produces only the very best quality of these keepsake publications. Look for our complete portfolio of books at www.panache.com.

We are proud to introduce to you the Panache Partners team below that made this publication possible.

Brian G. Carabet

Brian is co-founder and owner of Panache Partners. With more than 20 years of experience in the publishing industry, he has designed and produced more than 100 magazines and books. He is passionate about high-quality design and applies his skill in leading the creative assets of the company. "A spectacular home is one built for entertaining friends and family because without either it's just a house...a boat in the backyard helps too!"

John A. Shand

John is co-founder and owner of Panache Partners and applies his 25 years of sales and marketing experience in guiding the business development activities for the company. His passion toward the publishing business stems from the satisfaction derived from bringing ideas to reality. "My idea of a spectacular home includes an abundance of light, vibrant colors, state-of-the-art technology and beautiful views."

Annette Lightfoot

Annette is the associate publisher in Michigan for Panache Partners. Born and raised in Michigan, she spent six years of her entrepreneurial career in southern California building an international supply business. Living in both the Midwest and on the West Coast has really broadened her sense of style. "A spectacular home is designed to showcase an owner's personal style to guests, but more importantly allows them to enjoy their residence to the fullest extent possible."

Steven M. Darocy

Steve is the Executive Publisher of the Northeast Region for Panache Partners. He has over a decade of experience in sales and publishing. A native of western Pennsylvania, he lived in Pittsburgh for 25 years before relocating to his current residence in Dallas, Texas. Steve believes, "Family is what makes a home spectacular."

Beth Singer

Based in Metro Detroit, Beth has built a reputation for high-quality interior/exterior photography. Her ever-growing client base across the Midwest includes interior designers, architects and builders, as well as regional and national magazines, advertising agencies and the book industry. "A spectacular home inspires great photography."

Khristi S. Zimmeth

Khristi Zimmeth is an award-winning writer and editor based in metropolitan Detroit. After two decades in travel journalism, she now concentrates her efforts almost exclusively on interior design and gardens. "I love to see a house that's filled with interesting collections and one-of-a-kind souvenirs from travels," she says. "For me, a spectacular home is one that truly reflects the personality and passions of the person or people who live there."

Additional Acknowledgements

Project Management	Carol Kendall
Graphic Design	Emily Kattan, Mary Acree & Michele Cunningham-Scott
Production Coordinators	Kristy Randall, Laura Greenwood & Jennifer Lenhart
Editors	Elizabeth Gionta, Rosalie Wilson & Aaron Barker

The catalog of fine books in the areas of interior design and architecture and design continue to grow for Panache Partners, L.L.C. With more than 30 books published or in production, look for one or more of these keepsake books in a market near you.

Spectacular Homes Series

Published in 2005
Spectacular Homes of Georgia
Spectacular Homes of South Florida
Spectacular Homes of Tennessee
Spectacular Homes of Texas

Published or Publishing in 2006
Spectacular Homes of California
Spectacular Homes of the Carolinas
Spectacular Homes of Chicago
Spectacular Homes of Colorado
Spectacular Homes of Florida
Spectacular Homes of Michigan
Spectacular Homes of the Pacific Northwest
Spectacular Homes of Greater Philadelphia
Spectacular Homes of the Southwest
Spectacular Homes of Washington DC

Other titles available from Panache Partners

Spectacular Hotels
Texans and Their Pets
Spectacular Restaurants of Texas

Dream Homes Series

Published in 2005
Dream Homes of Texas

Published or Publishing in 2006
Dream Homes of Colorado
Dream Homes of South Florida
Dream Homes of New Jersey
Dream Homes of New York
Dream Homes of Greater Philadelphia
Dream Homes of the Western Deserts

Order two or more copies today and we'll pay the shipping.

To order visit www.panache.com
or call 972.661.9884.

Creating Spectacular Publications for Discerning Readers

Designers' Index